THE ART OF PENCIL DRAWING

THE ART OF
PENCIL
DRAWING

by Ernest W. Watson

WATSON-GUPTILL PUBLICATIONS · NEW YORK

Paperback Edition 1985

Copyright © 1968 by Watson-Guptill Publications

First published 1968 in New York by Watson-Guptill Publications,
a division of Billboard Publications, Inc.,
1515 Broadway, New York, N.Y. 10036

Library of Congress Catalog Card Number: 68–27552
ISBN 0–8230–0275–6
ISBN 0–8230–0276–4 (pbk.)

Distributed in the United Kingdom by Phaidon Press Ltd., Littlegate
House, St. Ebbe's St., Oxford

Manufactured in U.S.A.

1 2 3 4 5 6 7/90 89 88 87 86 85

CONTENTS

INTRODUCTION

Like thousands of art students across America, I was brought up on the books and magazine articles of Ernest Watson. I knew his writings by heart and studied his handsome pencil drawings stroke by stroke, trying to fathom the technique of which he's still a master at the age of 84. To a large and faithful following—a following that continues to grow—Ernest Watson is *the* author to read on the craft of pencil drawing. For this army of admirers, a new book by Ernest Watson is an event of particular importance because this is his most ambitious book on the subject —a subject to which he has devoted a large part of his professional life.

Having introduced the reader to the fundamentals of pencil drawing in an imposing parade of earlier books—many of them still available—the author now turns to the knotty and sophisticated problems of the advanced reader: the serious student for whom art will soon be a profession; the advanced amateur; and the professional who wants to delve more deeply into the disciplines of drawing. Thus, *The Art of Pencil Drawing* is unique among Ernest Watson's books. Purely in terms of technique, its scope is greater than any other book that bears his name; but equally important this is his most personal book, in which the author reveals the creative processes, both technical and philosophical, which underlie his art and his teaching.

For Ernest Watson began his professional life as both artist and teacher, and these have remained his dual vocations. Born in Conway, Massachusetts, in 1884, he concluded his art studies at Pratt Institute in 1907 and began teaching there the following year. His tour of service at that famous art school was twenty-one years; as supervisor of day and evening classes from 1919 to 1929, he met thousands of art students, and his profound feeling for young people is one of the secrets of his success as a teacher and as a writer of books that teach.

From teaching, Ernest Watson turned to educational journalism, serving first as Art Editor of *Scholastic* from 1931 to 1937. Then, sensing the public need for a magazine that would teach art techniques to the growing number of amateur artists and art students, he and the late Arthur Guptill hit on a remarkable publishing idea—the magazine which ultimately became the most widely read art journal in the world: *American Artist*.

As Editor-in-Chief of *American Artist* from 1937 to the end of 1955, when he became Editor Emeritus, Ernest Watson found the ideal way to combine his talents as artist, teacher, and journalist. Building upon the success of the magazine, Watson-Guptill Publications soon found itself publishing art instruction books. It was another "first"; this small, adventurous American publishing house was the first to

sense the coming art boom and to specialize in books that taught Americans to draw and paint. The continuing growth of *American Artist* and Watson-Guptill books—both begun at a time when today's art boom seemed a wild dream—is a tribute to the vision of both Ernest Watson and Arthur Guptill.

But Ernest Watson's extraordinary productivity as publisher, editor, and writer has been matched by his creativity as an artist. His beautiful color prints—remarkable for their pioneering use of the linoleum cut as a multi-color medium—are in such major public collections as the Smithsonian Institution, the Library of Congress, the New York Public Library, the Brooklyn Museum, the Baltimore Museum of Art, and the Boston Public Library. Watson also found time to make drawings for several national advertising campaigns. And he continues to produce a steady flow of superb pencil drawings which have greater freedom and vitality than ever.

Let me admit it: these drawings are a kind of secret motive in publishing this beautiful book. Except for the lucky few who've been allowed to turn the pages of Ernest Watson's private albums, his admirers have never seen a comprehensive range of his pencil drawings. Here, then, for the first time, is the cream of his previously *unpublished* work—drawings which are not only self-sufficient lessons in the art of the pencil, but works of art as inspiring as the man himself.

Donald Holden, Editor
Watson-Guptill Publications

AUTHOR'S NOTE

Frankly, I was cajoled into doing this book. Having written several books dealing with various aspects of drawing and picturemaking, I demurred at the suggestion of Editor Donald Holden that I write yet another. But editors can be very persuasive, as indeed was Mr. Holden, who journeyed to my New Rochelle studio and began leafing through portfolios of my drawings made here and abroad over many years. At the end of his browsing, I was reminded that the comments I had made about the drawings, as we were inspecting them one by one, would have been the basis for a book had there been a tape recording of our discussion. Thus the idea for this book had its beginning.

The drawings in those portfolios were made exclusively with the graphite pencil. There are many other kinds of pencils: carbon, charcoal, lithographic, even silver pencils. All will produce effective and beautiful drawings in the hands of creative artists who know how to use them. And there are different ways or manners of using any one of them, according to the preference and idiosyncrasy of the artist.

I have worked with all of these different tools and have learned what they will do. I have practically discarded all but the graphite pencil; I discovered a great many years ago that it will do everything I want to do with a pencil. It is a tremendously versatile tool, a claim which I once set out to demonstrate in a series of one hundred fifty drawings made over a period of twelve years for a prominent manufacturer of drawing pencils.

I was commissioned by the Joseph Dixon Crucible Company to produce a series of pencil drawings to be used as advertisements for their Eldorado artists' pencil. These drawings appeared, one each month, in the architectural magazine *Pencil Points* (now *Progressive Architecture*), in *American Artist, School Arts,* and others. They were faithfully reproduced at the exact size of the originals, approximately 9" x 12", the page size of *Pencil Points*. Although created for advertisements, these pages carried scant commercial messages. The text which accompanied each highlight halftone reproduction was of a technically instructive nature for the encouragement of the artistic use of this medium.

I was given absolute freedom in the selection of subjects. The commission took me, over a twelve year period, to Europe, England, Mexico, and many sections of this country. It took me also to art museums, where I was privileged to draw sculptures, ceramics, and other craft creations from the originals.

When recently I began assembling illustrations for this book, I journeyed to the offices of the Joseph Dixon Crucible Company to inspect these drawings, to select a number of examples printed here—and to revitalize my remembered experiences in doing them.

I mention this commission because it was a unique opportunity for exploring in depth the potentialities of the graphite pencil. Long before this, however, I had become a devotee of the graphite pencil, having used it commercially and having taught its use at Pratt Institute and in special classes for architects.

There has been a healthy resurgence of interest in pencil work of late years; collections of my drawings have been, and are now in circulation in many educational institutions.

Every artist makes use of the pencil, but I know of few indeed who have viewed it with such zeal as, for example, a watercolorist applies to the mastery of his medium. Usually the pencil functions as an adjunct to some other medium in experimenting with compositional arrangements. This is quite different from adopting it as an independent medium.

Like all other media, the pencil has its own special suitability for pictorial expression. Likewise it has its limitations. But limitations are by no means hindrances to creativeness. Often they stimulate it. The necessity for selectiveness when drawing with the pencil sharpens the artist's perceptiveness in pinpointing the subject's essential interest. This perceptiveness is enhanced also in the act of translating color into black and white expression. That in itself is a creative function. (Although I have not painted professionally, I experienced the entrancement of color while working for twenty years or more with color woodcuts.) When drawing with pencil, I never *think* color. One has to become color blind, as it were. A sacrifice of pleasure? I suppose so. Yet one attains such sensitivity to values that there is satisfying compensation for that loss. However, I am the first to agree that experience in working with color certainly is contributory to one's development in the mastery of any black and white medium.

Simple as my medium is, there is a lot to say about its use. On the following pages, I shall try to demonstrate some of the things you can do with this pencil. This is not a step-by-step kind of presentation. Nor does the arrangement of its chapters follow a calculated progression from elementary to more advanced work. The drawings shown represent a variety of themes and solutions, which I trust will be instructive as well as inspiring—knowing from my own experiences that one learns best through example.

In closing these brief remarks, I want to acknowledge with gratitude the collaboration of my wife Eve, who has contributed her editorial know-how to this work.

Ernest W. Watson
Threshold
Mulberry Lane, New Rochelle, New York
January, 1968

THE ART OF PENCIL DRAWING

There are a great many ways to use the pencil. I have already explained—in the "Author's Note"—that I have concentrated upon the graphite pencil as my favorite medium. What I shall have to say about materials, as well as the drawings themselves will apply in large measure, therefore, to what is known as the *broad-stroke* technique.

The principal ingredients for success in this use of the graphite pencil—and this applies to all media—are practice and experimentation. In other books written for elementary students, I have gone into greater detail than seems appropriate in this advanced treatise, wherein I stress conceptual problems and advanced techniques. But there are a few instructions about materials which should be offered to anyone, however advanced, who for the first time may be exploiting seriously the pencil as a medium.

SIMPLE MATERIALS AND EQUIPMENT

The convenience of the pencil in outdoor sketching is obvious. It allows one to get into places where watercolor or oil would be out of the question. The equipment needed is simple and inexpensive: a portfolio to hold drawing papers and a few pencils to carry in one's pocket. The portfolio serves as a drawing board. Two large rubber bands will hold the paper securely to the portfolio. A folding camp stool is indispensable; a light metal and canvas one which folds to about 8″ x 15″ will serve. It is carried easily, along with the portfolio, under the arm. A substantial wooden stool is more comfortable and is practical when traveling by car. One more important item is the kneaded eraser, which is a *must* for pencil work.

SHAPING THE LEAD

The pencil is not a tool for rendering large tonal areas such as are natural with the brush; but when used with restraint, in reasonably restricted areas, it yields charming tonal suggestions which are its principal claim for preeminence as a medium. To perform best in this manner the lead (we still speak of "lead pencils," the term lead referring now only to the pencil core, regardless of its chemical base) has to be given a bevel point, if a bevel can indeed be called a *point*. This bevel results when the pencil, held in a natural writing or drawing position, is worn down by abrasion on a piece of paper as in Figure 1, the pencil being held in an identical position until the stroke it makes becomes as wide as the diameter of the lead allows, if such

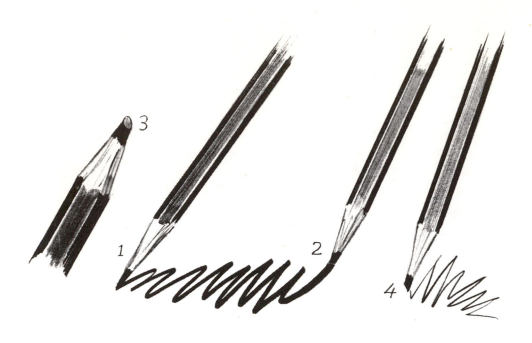

Figure 1. Preparing your Pencil for Broad-Stroke Technique

The broad-stroke technique is a natural way to use the pencil, for it takes advantage of the maximum width of the pencil lead. For this technique, the pencil lead should be worn down on a piece of fine sandpaper (or any rough paper), until it has a point like that shown in 3. Start with the pencil sharpened as in 1, by tapering the lead slightly, instead of merely cutting away the wood. Then wear the lead down until you have a flat-surface point suitable for broad-stroke technique like that in 2 and 3. When this point is turned over, it will give sharp, thin lines as in 4.

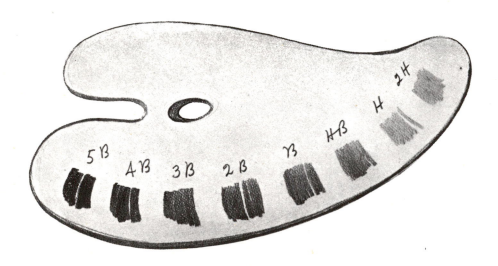

Figure 2. Tonal Palette

This tonal palette serves as an approximate key to the use of varying degrees of pencil lead —hard to soft. Not all of the numbered pencils are likely to be used by the artist in any given sketch. Three or four, maximum, usually suffice.

is desired. Soft leads have larger diameters and therefore will yield wider strokes. This kind of point is quite different from a chisel sharpening, which would be most awkward to use.

When, in the course of drawing, the pencil is laid down and then taken up again to resume the same stroke character, it must be held in the hand in exactly the same position as formerly in order that the bevel will contact the paper as before. One always has a scrap of drawing paper on the board for trial. This is equivalent to testing a watercolor brush to be assured that it is charged with the desired color.

The resilient surface provided by *several* sheets of paper between a hard board and the drawing permits the pencil edge to bite a trifle into the paper and yield more positive strokes. The strokes will have well defined edges. This is an important condition for working in *broad-stroke,* as this technique is appropriately called. It has also been referred to as *pencil painting.*

The development of facility in broad-stroke requires practice: fill many sheets of practice paper with stroke experiments to hasten the point of proficiency. Bevel points, used for broad-stroke, will also produce sharp, thin lines when the pencil is turned in the fingers.

PAPER

When we talk about the technical aspects of pencil drawing, we must consider paper as well; what is done with any degree of pencil lead is conditioned by the paper being used. On paper having the roughest tooth, lighter pencils will produce darker tones than if used on a smooth surface. Some surfaces yield a surprising range of desired values; others are limited.

If you can find a clay coated paper, you will have the most receptive surface ever made available for pencil drawing. Such papers, named *Video* and *Media,* are sold at Arthur Brown's art supply store at 2 West 46th Street, New York City, and are available in many other cities. Or any dealer should be able to secure them for you from Arthur Brown. The papers are sold in pads of convenient sizes. They are expensive papers, but are worth whatever they cost.

The clay coating permits scraping out with a sharp knife edge or with a razor blade. I use a single edge razor blade which must be *sharp.* This enlarges technical possibilities enormously. White tree branches can be scraped out from a dark foliage mass; white accents can be introduced where needed in any tonal mass; even small areas can be removed in this way. You cannot use an eraser on clay coated paper.

Bristol boards are sometimes excellent. One of my favorite papers bears the trade name of *Aquabee Satin Finish,* made by Bee Paper Company. Another paper which I've used extensively is *Alexis,* made by the Strathmore Paper Company; it has been available in stores for as long as I can remember.

If there is not a large art supply store in your town, a trip to a nearby art cen-

ter is worthwhile to collect sample papers. An assortment of the *right* papers is essential for those who are serious. More will be said about papers in my comments upon drawings reproduced on following pages. Oh yes, the weather! We must not overlook the weather as a factor. On a damp, foggy, or rainy day, paper has a way of responding most unsatisfactorily. Paper absorbs moisture and becomes less receptive to any pencil. When in this damp condition, softer leads will be needed to do what can be done with much harder leads when the weather is clear and dry. Of course the paper can be dried out in the kitchen oven before using. Any diagrammatic scale for specific tonal effects is based upon *dry* paper conditions, so this scale is only approximate in wet weather.

PENCILS

In placing so much emphasis upon paper, we are reminding ourselves that pencil and paper are equal partners in the creation of technical harmonies. In this connection, we must realize that the grading of pencils (H for hard, B for soft)—by numbers that indicate their degree of hardness—is far from a science. A relatively soft pencil labeled 4B in brand X is unlikely to be identical with the same label on a brand Y pencil. Often they differ radically in this respect. So, when I state in captions that certain degrees of lead were employed in a certain drawing, the reader is advised that the designation is approximate; it is by no means as reliable as the identification of a musical note on the keyboard of a well-tuned piano. My references to labels, therefore, can designate only such textural relationships as were involved in that sketch; and that I used the same manufacturer's brand throughout.

So far as I know, the familiar American brands are not made in leads softer than 6B. A German pencil named *Stabilo* is available in soft leads up to and including 8B. These were not available in my earlier sketching years.

TONAL PALETTE

In a book I wrote many years ago, now out of print, I used an illustration of a tonal palette which served as an approximate key to the use of varying degrees of pencil leads—hard to soft. It is a good way to remind the student that a considerable range of leads should be carried in one's sketching kit. If this palette (Figure 2) looks a bit frightening, I should explain that not all of the numbered pencils are

Figure 3. Chinese Stone Head

A soft pencil lightly applied to a rough-surfaced paper produced the grainy, charcoal-like effect. Darker, smooth tones were achieved by working the sharp point of the lead into the grain of the paper. I rubbed a stump over the black tones of the headress, and stroked my finger lightly over the cheek area. The lighted side of the face, which contrasts with the tones of the background and shaded areas of the head, is untouched paper.

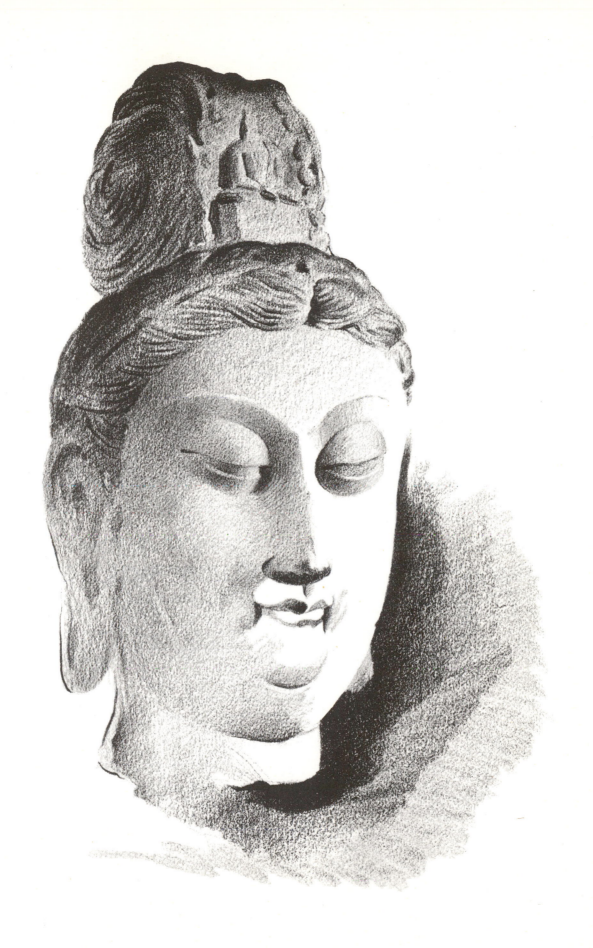

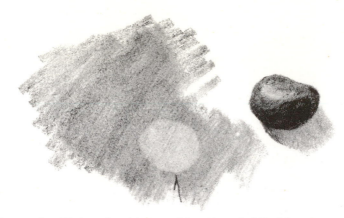

Figure 4. Lightening Tones with a Kneaded Rubber

By pressing down on your pencil tone with a piece of kneaded rubber, you can lift off and lighten desired areas. Avoid rubbing or erasing which smears the tones.

Figure 5. Cutting Light Accents

A piece of kneaded rubber pinched to a sharp edge will cut light accents into pencil tone.

Figure 6. Tortillon Stump

The tortillon stump, a tightly rolled paper cylinder which is tapered to a point, should be used sparingly. Used too freely, the stump will destroy the characteristic quality of the pencil.

likely to be used by the artist in any given sketch. Usually three or four numbers are adequate for any subject; and on certain surfaces, mentioned later, two or even one will suffice.

The softest lead will of itself produce a complete tonal range on almost any paper. However, as one soon discovers in experimenting, the tones of a soft pencil become less smooth in texture, more grained in effect, as they approach the lightest extreme of the scale. This is not always a disadvantage; indeed, that kind of rough texture was important in drawing the Chinese stone head (Figure 3). A sketch made exclusively with that one softest lead can be handsome. But at the moment we are concerned with a smoother technique.

As the drawings in this book are studied, a good many technical characteristics other than my usual broad-stroke will be noted. There is the sharp staccato needed for drawing members of the palm tree family; thin, vigorous lines for some branches; delicate, sensitive lines for others. Sharp outlining strokes for rock masses, and staccato short strokes to relieve a too-pallid mass—these are a few of such uses. Sometimes a broad wash-like effect can be dramatic; this is done by holding the pencil nearly lying on the paper, using not the lead's point, but the side of its length. Experiment, experiment, experiment!

ERASER

The kneaded eraser is so called because the rubber, in cake form, is soft enough to be kneaded between thumb and fingers. It is the *only* eraser I ever use in pencil work. It will not smear the graphite as do other erasers. One does very little "erasing" with this rubber! Once the paper has been erased by actually *rubbing*, the surface loses its freshness and receptivity; but a tone that has been rendered too dark may be lightened by pressing the rubber down upon it *without* rubbing, as illustrated in Figure 4. This is a good clean-up eraser.

Kneaded rubber is useful for cutting small, light accents into pencil tone as illustrated in Figure 5. To do this, the rubber is squeezed into a narrow edge.

Kneaded rubber remains pliable in warm weather, but when the temperature drops, it hardens. If placed on a radiator for a few moments, the eraser becomes soft again. I usually carry an eraser in my trousers pocket.

TORTILLON STUMP

The tortillon stump is a tightly wound paper cylinder which tapers at one end. It is designed for rubbing tones of pencil, charcoal, or crayon. It should be used sparingly because too much blending of pencil strokes deadens the fresh look which is the special charm of the medium. Figure 6 illustrates how the stump modifies the effect of direct strokes, giving a wash-like appearance.

Up to this point, I've been speaking principally about one aspect of pencil

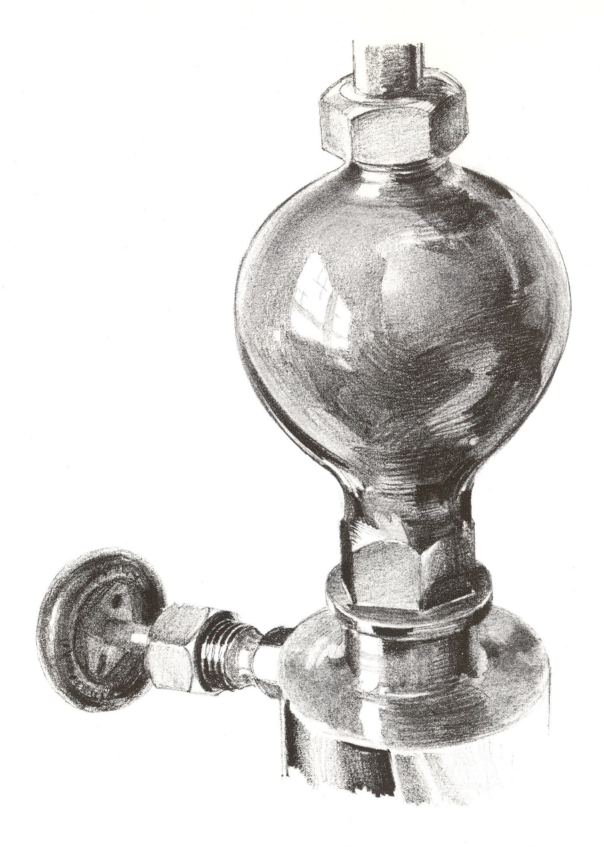

Figure 7. Rendering of Brass Valve

The pencil is ideally suited for rendering the subtle tonal patterns of brightly polished brass. I used 5B, 4B, and 2B leads on a slightly toothy paper.

Figure 8. An Abstraction

I seldom do this type of rendering with the pencil. This drawing is one of a series, produced for the manufacturers of the Eldorado pencil, designed to demonstrate the many techniques of which it is capable. The technique here might be designated as semi-photographic, relatively smooth rendering, in contrast to the direct handling method, which exploits the charm of stroke technique. It is a somewhat laborious tonal method, yet I was surprised to find, after I began this series, that it was rather fascinating. And, as you can see in this example, the identity of the pencil is not wholly submerged by this atypical technique. I created the entire series of abstractions on heavy white drawing paper, with three or four degrees of leads. Some, like the one here shown, were based upon well known forms. Others were entirely abstract. The constructions were placed in a shadow box and illuminated by a 150 watt spotlight to insure dramatic light and shadow effects.

technique, the broad-stroke method. The rendering of a brass value (Figure 7) shows how polished surfaces may best be simulated by building up tone with more or less pointed leads, rubbed here and there *cautiously* with the tortillon stump or finger to produce the characteristic smooth surface of such an object. But along with the smooth technique in this drawing, there is enough direct line work to vitalize a rendering which easily could have become photographic.

Such a polished globular surface is alive with reflections. Aside from the highlight that reflects a window in the shop where this drawing was made, all other light reflections are muted, and they blend into the darks in smooth transition. We are not conscious of the pencil point in this rendering except, as already stated, for the few forceful line strokes, here and there, which serve to contribute a sense of vibration. The few white strokes are untouched paper, not scraped out as they could have been had the surface been clay coated. For this drawing I used Strathmore's *Alexis* paper.

It is probable that the kneaded eraser played a part in this rendering, not by rubbing out, but by pressing down and *lifting* the tone here and there. The eraser must be very soft and pliable to serve in this manner.

(The abstraction, Figure 8, was also rendered with the point rather than the broad-stroke bevel edge.)

CHARCOAL EFFECT

The drawing of the stone head from the T'ang Dynasty of China (Figure 3) shows how the pencil can be employed in a charcoal-like manner. The charcoal effect of this drawing was simulated by using a very soft pencil on a rough surfaced (though not charcoal) paper. In such a pencil-paper combination, the pencil lead skims over the paper lightly, except in the very dark areas. In some places, as around the eyes and the lips, a sharpened point, worked into the depressions of the paper's grained surface, produced the darker, smoother tones. The very top of the head piece was rubbed into a jet black tone with the stump, which was also rubbed lightly on its front. Nowhere else in the drawing was the stump used, but the shaded cheek and nose were stroked lightly with the finger for a rather smooth texture.

The background tones that fan out from the cheek and neck were produced by the *side* of the lead, with the pencil held as one would hold a charcoal stick. The

Figure 9. The Chain Gate, Wells Cathedral, Somerset, England

This drawing attests to the pencil's great versatility and power as a tool for rendering architectural subjects. I began by making a meticulous rendering of the subject in light line, and then placed the darkest values to establish the tonal limits of the drawing. All other values were keyed accordingly.

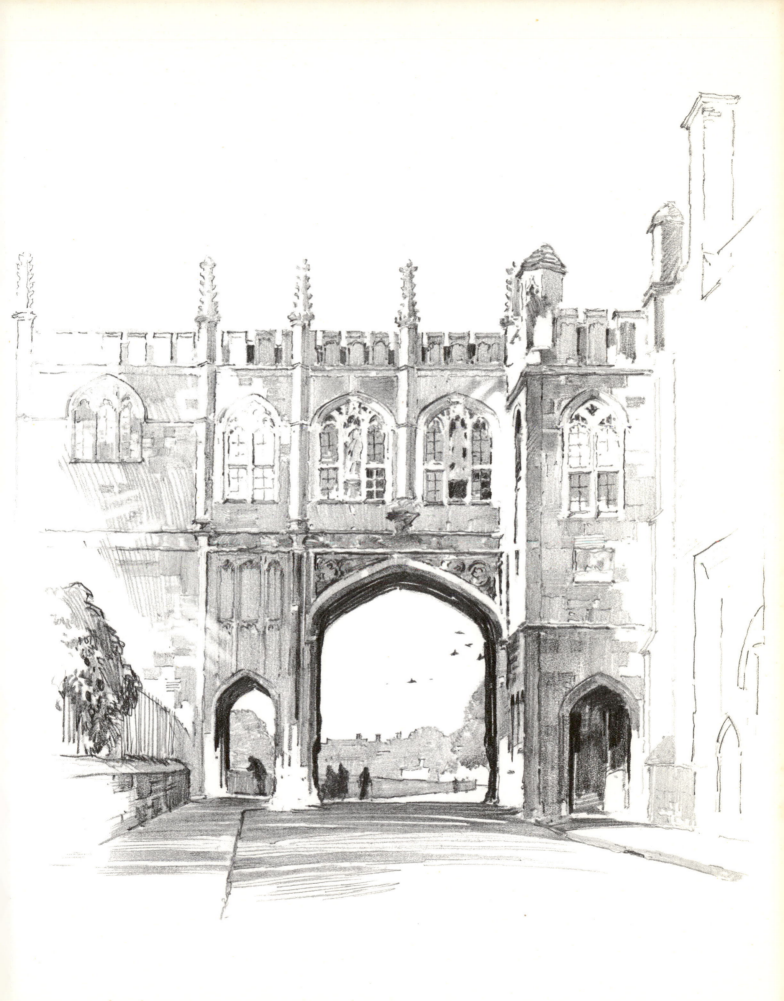

pencil was pressed down hard on the paper for the black areas that outline the cheek and the neck. This drawing and that of the brass valve were among those made as advertisements for Eldorado Pencil.

VERSATILITY OF THE PENCIL

I had the good fortune, many years ago, of spending a week in the beautiful cathedral town of Wells in Somerset, England. I made many drawings there.

An architectural subject like *The Chain Gate, Wells Cathedral* (Figure 9) challenges the draughtsman who works entirely freehand as I always do, without benefit of straightedge or ruler. My too brief, though very useful, study of architecture stood me in good stead in rendering this subject.

If possible, one always chooses the best time of day for the favorable light and shadow aspect of his subject even if, for one reason or another, this may be none too convenient. In this case, it had to be a Sunday morning. In order to obtain the preferred view, I was obliged to establish my position near the middle of the road leading to the arch. This road soon became a busy thoroughfare for the worshipers bound for the Sunday morning service, and I found myself in the path of their approach. However, these friendly people—I have always found the English such—simply flowed around me, a trivial detour that created no problem at all. Long ago, I became accustomed to drawing with wayfarers about, some of whom stand behind and look over my shoulder. This is all right so long as I am not expected to answer questions by too inquisitive observers.

The first step in the drawing, of course, was a meticulous layout of the structure in light line—giving me freedom to begin the tonal rendering. Before beginning even the first line drawing, I had, on previous visits, visualized the tonal effects that would best express my impressions of the subject.

Rendering, as usual, began with the darkest values—in this case the shadowed arches and the few black window accents. These define the limits of the tonal range throughout, all other values being keyed to them.

An essential aspect of the picture is the sunlit face of the projecting mass at the right of the main arch. This had to be kept white to intensify the effect of sun shining brightly upon the structure. White is so essential in tonal work. Consider, for example, the white accents at the bases of the vertical arch supports. These are

Figure 10. Ruined Columns, Temple of Zeus

This drawing was made primarily to demonstrate the potential of the pencil in direct, vigorous, broad-stroke rendering, with jet black tones—such as you see under the architrave supported by the columns with their Corinthian capitals. A clay coated paper like Video or Media is most receptive to rendering very dark tones, but it is equally inviting to light values. Notice the sharp, thin lines in the architrave. The clean white lines within the shaded flutes of the columns also contribute to the dramatic effect of the drawing.

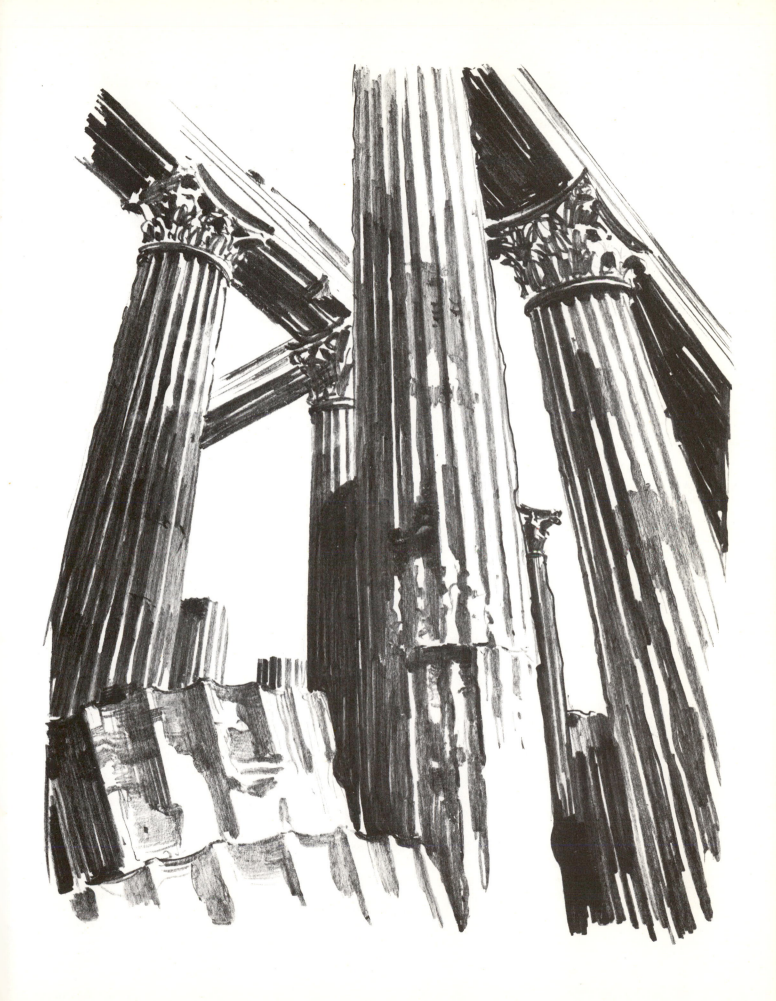

purely arbitrary as the gray tone of the masonry naturally covered these details to the ground.

In pencil drawing, one always avoids any leaning toward photographic simulation—thus the intrusion of white diversions like that over the upper left window, and the tonal break in masonry rendering, which gives pattern interest to the wall over the small doorway at the right of the main arch. This kind of patterning is also a device for "getting out of the picture" gracefully. On the left side, this necessity is served by resorting to open-stroke technique. The suggestion of sunlight streaking into the scene, as noted here above the left arch, can often be used to good advantage in enforcing the impression of sunlight—if the device is not overdone.

The importance of that dark bush or vine overhanging the iron fence is readily seen if it be covered by a piece of white paper.

I call attention to the rendering of the street, which I think is quite successful in this drawing, very dark under the arch, gradually lightening in tone as it comes forward, and then tapering off in an open, linear technique.

Let me refer again to that facing wall at the right of the arch. Photographically, this wall would doubtless present a uniform gray value to the camera eye, although it might, to be sure, be somewhat modified by reflected light from adjacent walls. However, in my rendering, the shaded tones vary radically from very dark value at the arched door to lighter tones above, again becoming very dark above, where contrasts seemed advisable.

I've taken a lot of space to discuss this drawing because it embodies so many qualities that testify to the great versatility and expressive power of the pencil in rendering architectural subjects. And then I like to talk about an experience which thrills me in remembrance, as this one does.

FIXATIVE

Often the question is asked, "Should one 'fix' pencil drawings to prevent damage by rubbing when they are handled?" I have always avoided the use of fixative. Many of my sketches were made prior to the invention of acrylic fixatives, which doubtless are far superior to the old shellac and alcohol type which did stain the work

Figure 11. The Main Portal, Rouen Cathedral

This light-toned, delicate rendering follows the bold drawing of the ruined Greek Temple of Zeus (Figure 10) in order to dramatize the vast range of potential expression of the graphite pencil. The great cathedral doorway, of course, is the focal point here; but while the other forms may seem intentionally subordinate to it, this is not the case. It seemed to me that the lacey detail of the glorious façade above could most appropriately be realized by rendering it in very light tones. While meticulously delineating the area just over the arch, the detail of the two flanking spires has been treated suggestively; and the forms above are so indefinite as to rely upon the viewer's imagination for completion.

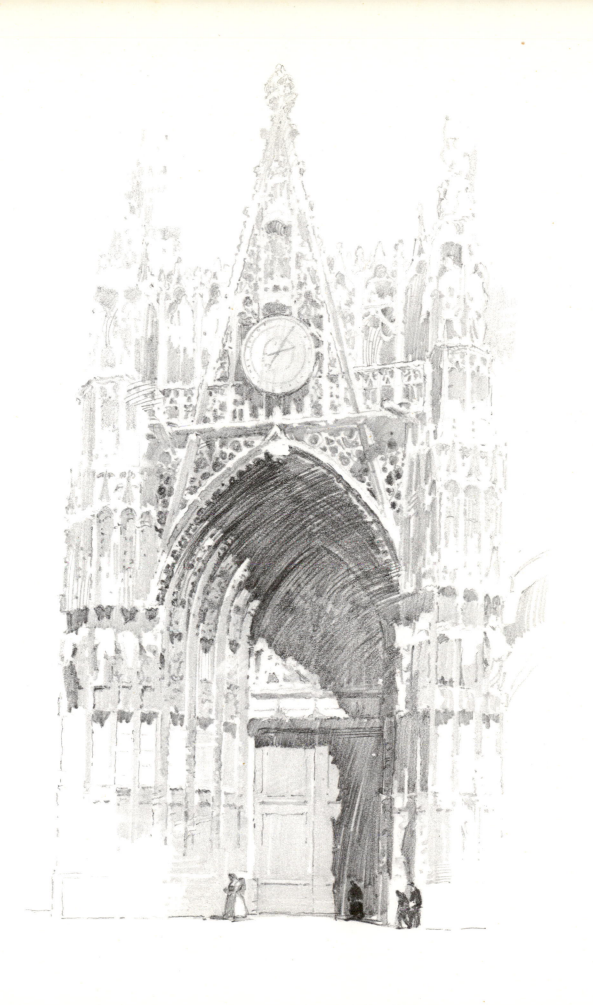

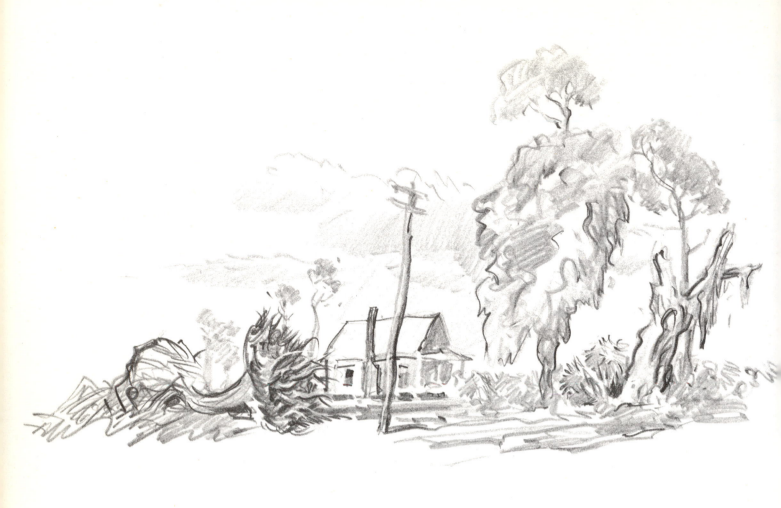

Figure 12. Uprooted Tree And Cabin In South Carolina

The uprooted tree was the real reason I stopped along the road to make this drawing. It took no more than twenty minutes. Note the broad-stroke technique used in the tall tree and the dead trunk. The clouds play an important part in the composition, holding together elements that would otherwise be scattered. There is much profit in rapid sketching. It compels a degree of spontaneity which is later reflected in more carefully studied drawings. It certainly encourages the use of broad-stroke technique, which has a rapid covering effect.

yellow over the years. The modern spray fixatives (which come in aerosol cans) may have no such unwelcome effect on drawings, but I continue to avoid fixatives of any kind.

I have referred only to a limited number of "ways" in this chapter: captions that accompany all of the sketches reproduced in this book will encompass many others. This seemed to be the most direct means of presenting the subject.

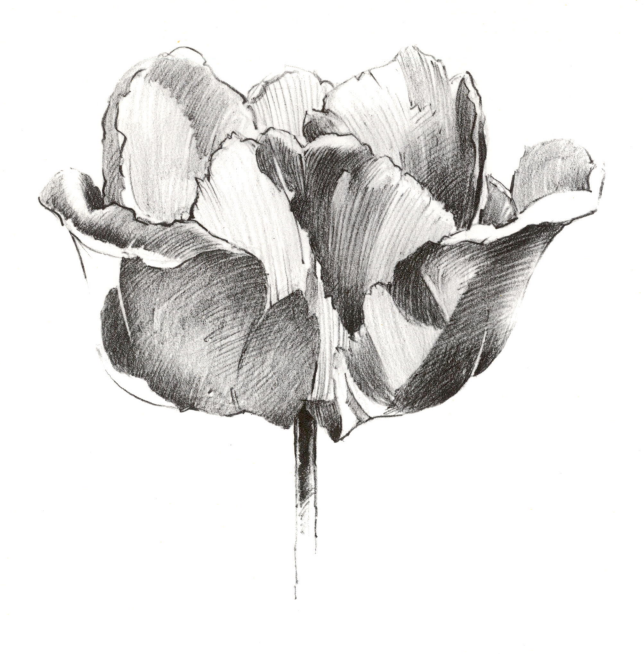

Figure 13. Magenta Tulip

An hour of intense, concentrated work went into this study of a single bloom in full sunlight. A profound exercise in seeing, I searched out shapes, color contrasts, textures, and shadow patterns. Though I copied the forms meticulously, no attempt was made to achieve botanical accuracy. Collection and courtesy, Dr. and Mrs. Frederick C. McLellan.

There is a vast difference between looking and seeing—a difference which is fundamental to the artist's experience in communicating whatever object or scene with which he becomes esthetically involved.

GOING TO THE HEART OF THINGS

Looking is but a superficial experience which does not promote intimate acquaintance, does not go to the heart of things. Indeed, it can be (and often is) of so transient a nature that it makes only a casual impact upon our consciousness. We look but we do not see. We may be made aware of this gap between looking and seeing if asked, for example, to describe the furnishings of a room in which we have been visiting. We may even be unable to make a drawing of the front of an automobile we have been driving for years.

The physical eye, it is evident, is nothing but a tool, albeit a marvelous tool. Like all tools, it is but a means to an end. It operates to a significant purpose only when the door of awareness is open. It may be likened to a camera lens, which is useless without a sensitive film behind it, waiting to receive impressions and vividly record them. The eye does not do the seeing; it does not do the perceiving. We see, *really see,* when we lose self-consciousness in contemplation of scenes, objects, or events. Only then can we be said to *integrate* with the subject, become a part of it as happens when we witness an absorbing drama or watch a major league game. When we really see, we transcend our own individuality, forget self, and become engrossed in a visual adventure.

AN EXPERIENCE IN A GARDEN

That is the way it was with me when, one sunny morning, I drew the tulip reproduced in Figure 13. Reclining in a lawn chair within reach of our full-blown tulip garden, I was wholly preoccupied with a serious problem. I was depressed. In a moment of relaxation, my gaze fell upon some magenta tulips. I had never before *seen* a tulip. Oh, I had looked at tulips in a long succession of springtimes and had gloried in their beauty when their colors blazoned like the gamut of color on an artist's palette. I had watched tulips sway lazily on their long stems in gentle breezes, and tremble with seeming disapproval when agitated by gusty winds. Yes, I had looked at innumerable tulips in a detached and agreeable kind of way for as long as I could remember; yet, until this occasion, I had never really *seen* one.

Suddenly, at this moment I began to *see* these flowers. It was as though they had reached out to me. I found myself focusing upon a single bloom in full sunlight. I was seeing a tulip! I was drawn into it. I felt an urge to sketch the flower and I went to my studio for paper and pencil.

CREATIVE SEEING

I spent a full hour seeing and drawing that tulip. I searched its shapes, its color contrasts, its value relationships, its textures, its shadow patterns. I copied the forms meticulously, though not from a botanical viewpoint. My drawing probably would not satisfy a botanist because it was a translation into terms with which he could not be familiar. He would not have seen what I saw, as I must have missed what he would be looking for. Each of us would necessarily see a tulip in different ways, and both of us could maintain that we had indeed *seen* it, though not in its completeness.

I like what William Saroyan once wrote about seeing: "There is such a thing as creative seeing. What constitutes such looking? Clarity, intelligence, imagination and love. You make a point of looking at the object. You look steadily and clearly. You see the object, you see it again. You notice the true nature of it in its entirety and in its parts. You relate its reality to all reality, to all time and space and action. You admire its survival and you love its commonness and its individuality."

Now this may sound esoteric, but Saroyan was trying to put into words what can only be felt. And he made a mighty good job of it.

COMMUNICATION BETWEEN ARTIST AND OBJECT

Yet Saroyan did not state the whole truth of the matter. The artist employs even more than eyes and brain; his muscles creatively enter into the seeing process. Without making a graphic record, the seeing process is still incomplete. The action of the arm and hand make a recognizable contribution to the phenomenon. Thus, through collaboration of eye, brain, and muscle, we go beyond *knowing about* to the intimate experience of *knowing,* which is the basis of creation. There is reciprocal communication of viewer and object. It is a very real experience, this merging of oneself with the life of the object, even though it be an inanimate object. This may seem like a metaphysical concept, and it is, yet it is a very real phenomenon, and those of us who draw or paint creatively are well aware of this intercommunication between artist and object.

Consider, for example, our comparative responses when drawing from a photograph and drawing directly from the object. There is a deeply sensed intimacy between artist and object when both are parts of the same scene, both immersed in the same atmosphere, as it were. Is that not why a sketch—our sketch, however slight and lacking in detail—has infinitely more meaning to us than a fine photo-

graph of the same subject, or a painting of it by another artist? I think this explains in part the therapeutic value of drawing and painting for amateurs, although they doubtless are not consciously aware of it. The inspiration of "being with" transcends the mere ability to create a reasonable facsimile.

I have gone to some length in discussing this concept of creative seeing because I believe that a conscious awareness of its impact upon one's drawing experience is both pleasurable and inspiriting.

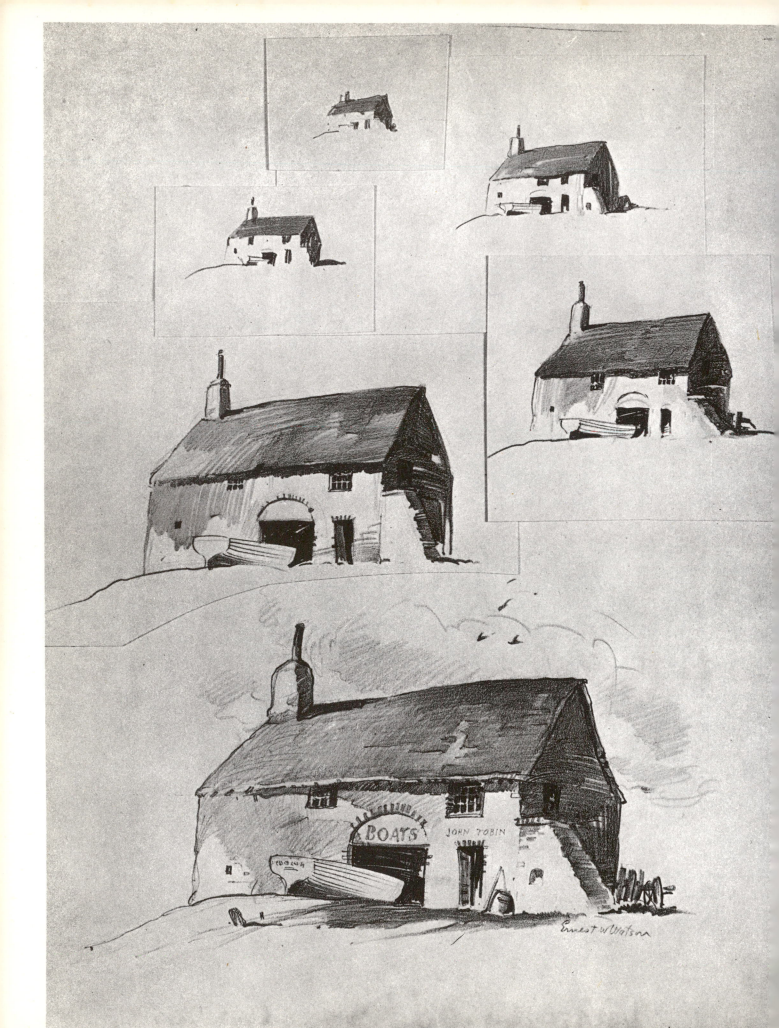

BOATS JOHN TOBIN

Ernest W Watson

3 SIZE AND COMPOSITION

One of the first decisions an artist must make concerns size. How large shall he plan his sketch or his painting? The way he answers the question is important. It may mean the difference between success and failure; at least it will qualify his success. There is *just the right size* for his work, whatever it may be.

TIME, WEATHER, AND OTHER CONSIDERATIONS

There are many factors to be considered. One is time. It would be folly for the painter to take along a large canvas when for one reason or another—rapidly changing light, for example—he will have not over an hour for his sketch. The necessity for quickly recording some moving action is another. The inconvenience of a large canvas on a windy day or in a busy thoroughfare is still another factor. Most painters confine their outdoor sketching to small panels that fit in their paint boxes, or to relatively small watercolor papers.

SIZE AND MEDIUM

But aside from these contingent factors there are others—inherent in the various media—which impose definite limitations. It is technically possible to make a pen sketch 20″ by 30″, but no one would think of doing it. A 20″ x 30″ canvas, on the other hand, presents a relatively small scale for a painter in oils, a medium that can manage a 20′ x 30′ mural gracefully. Watercolors are kept within narrower space limits, as are pastels. When handled broadly, the pencil—which, like the pen, is a point medium—will produce a stroke many times as broad as a pen line. However, it is not a medium for large scale work. Architects, to be sure, do make pencil renderings four or five feet long to visualize proposed buildings for their clients. But we are discussing sketching, and are not concerned with these elaborate drawings intended to illustrate details, suggest textures of building materials, and give an impression of the whole design.

Figure 14. **Six Drawings of a Boathouse, Cornish Coast, England**

These six sketches are reproduced at exact size to suggest how the structure might be rendered when seen at varying distances. The largest and most detailed sketch is a close-up. The smallest drawing illustrates how the boathouse would appear at a distance of about a quarter of a mile. Detail disappears with distance.

SIZE AND SUBJECT

Do not make your pencil drawings too large. What is *too* large? The answer depends somewhat upon the subject. A castle or a skyscraper may suggest a larger drawing than a boathouse, but an 8″ x 10″ pencil drawing of a castle is as large as I would attempt. I almost never work larger than that, and my preference is for an even smaller scale. The largest sketch of the boathouse (Figure 14) is reproduced at exact size of my original. For beginners, I strongly recommend very small drawings; novices will thus escape the danger of becoming hypnotized by detail.

It is by way of illustrating some of these size factors that I have made the six drawings in Figure 14 of the boathouse originally sketched on the Cornish coast of England. They are reproduced at exact size, and are intended to suggest how the structure might be rendered when seen at varying distances.

The largest is obviously a close-up. It is, as I have said, as big as I would care to sketch it in pencil, and it has all the detail afforded by the subject. To draw it larger would force the pictorial details at the expense of general effect. The smallest sketch is the way the structure might appear at a distance of, say, a quarter of a mile.

SIZE AND TONE

Seen at a distance, light and shadow show a limited range of values; there are no very dark tones. As we come nearer, the darks appear. When we are close to the subject, we see its complete tonal gamut.

But it is well to keep in mind the simplified light and dark pattern of that far distant effect when working on our close-ups; otherwise we run the risk of losing clarity and sense of volume. In larger drawings, it is very easy to become so diverted by illustrative detail that the big pattern—hence compositional power—is sacrificed. It is fairly common practice among artists to preface their final drawings or paintings with thumbnail sketches which help them to see their subjects in simple and effective patterns.

SIZE AND DETAIL

Large drawings simply demand detail. There should be no inactive areas. Every part of the picture must have something to say. When a large area is devoid of illustrative interest, the drawing fails to convince; it looks empty. In this connection, refer to the various treatments of the boathouse roof. In the first four sketches, the roof is so small that the textural interest of the pencil strokes themselves satisfies the need for detail.

In the fifth drawing we begin to feel the need for greater interest in the roof; and in the largest one, it was necessary to give a definite impression of an ancient patched roof that probably leaks during heavy rains. The roof of the fifth sketch would look unfinished if duplicated in the sixth drawing.

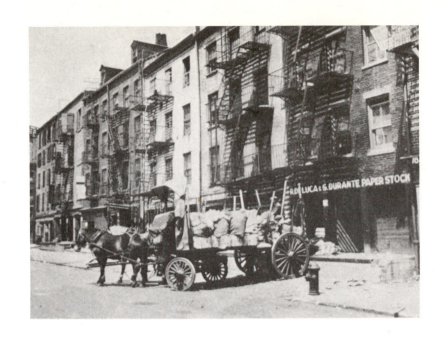

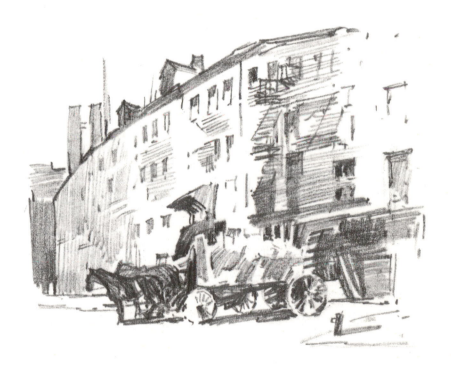

Figures 15 and 16. Photograph and Sketch of South Street, New York

The photograph of a team loading at the curb of South Street, New York (top) was taken "way back when." The pencil sketch made from the photograph (bottom) suggests how attention can be focused upon the point of interest through subordination and emphasis of elements.

It is safe to say that most beginners get into a lot of trouble by working too large in any medium. They set themselves tasks that would worry even practiced artists. In large scale, it is so difficult to get what we call "quality." Of course factors other than size enter into quality—such things as the right paper and proper grade of pencil, to mention two.

I should remind the reader that the foregoing remarks about size apply only to drawings that have no purpose beyond their own charm. Painters, accustomed to large scale work with the brush, often make sizeable pencil notes purely as records or as studies for paintings. They do this with no thought of producing drawings to delight the eye.

SIZE AND ARTISTIC TEMPERAMENT

There is still another factor that must be considered in our discussion of size. That is the artist's own temperament. Some people naturally do their best work at small scale; others can function only at large size. "Large scale" people usually write with a bold, scrawling hand. They like to draw with arm movement rather than finger movement. These individual, temperamental qualities ought to be considered; they are important. The large scale person probably will never be as effective with pen and pencil as with charcoal, pastel, or painting media. The scale which suits him is something each individual must discover for himself.

COMPOSING THE SKETCH: SELECTION, SUBORDINATION, EMPHASIS

To illustrate my discussion of composition, I am going to take you back to days that most of you were too young to remember, if indeed you had been born. Looking through my picture file recently—from days when I took my camera on walks through New York streets—I pulled out this photograph of a team and loaded cart standing on South Street (Figure 15).

Here is a rather fascinating subject, which I probably would have sketched had there been time, that day, before the wagon pulled out from the curb. All I could do was make this photo record, but now it is useful to demonstrate how one focuses upon the center of interest by removing the camouflage of its environment. The wagon and cargo are clearly silhouetted against the shadowed background, but the horses are lost in the confusion of the darkened buildings.

The tiny pencil sketch (reproduced at exact size in Figure 16) demonstrates

Figures 17 and 18. Photograph and Sketch of Theatre of Marcellus, Rome
Here, the photograph (at lower right) and final drawing pose a problem of simplification and pattern similar to that in South Street, New York (Figures 15 and 16). Both subjects required an illustrative approach that would give the illusion of reality, yet create a pattern that would direct the eye to a desired focal point.

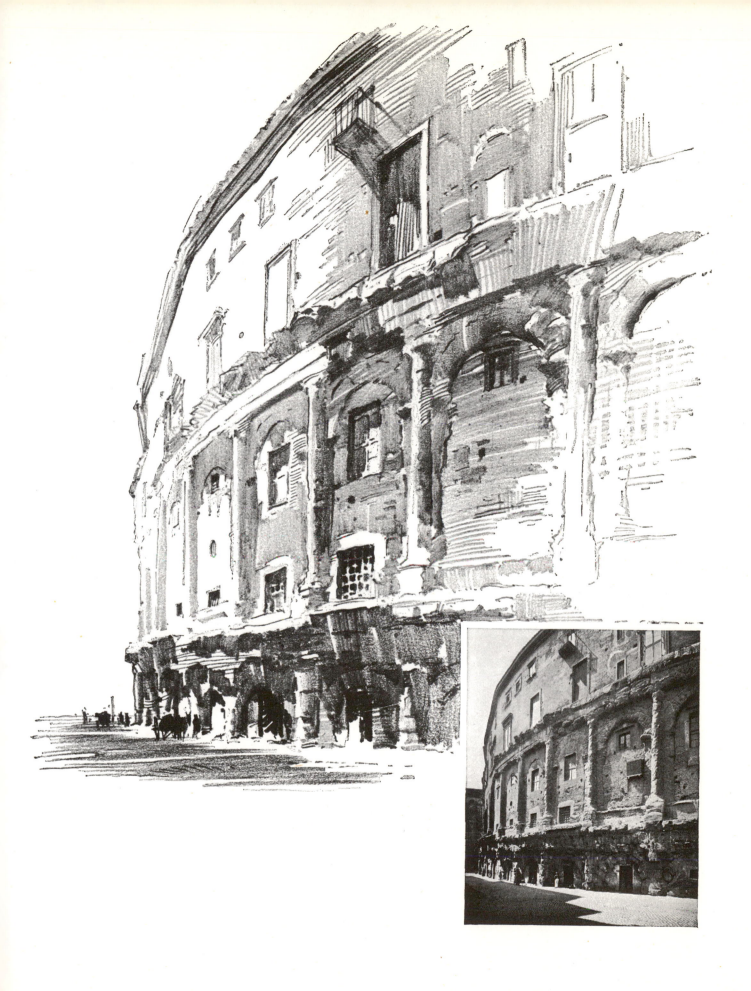

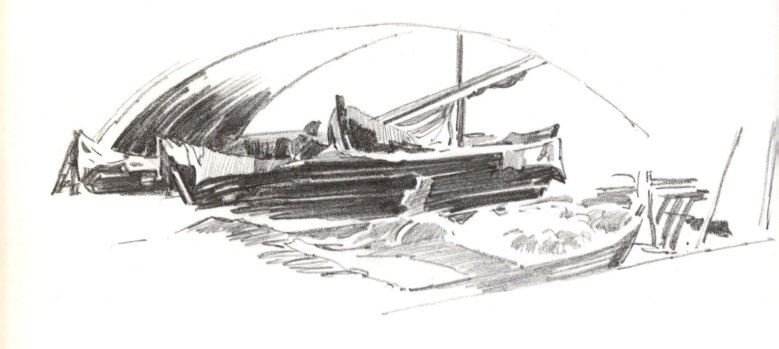

Figures 19 and 20. Ponte San Lorenzo, Venice

In this drawing, the barges under the bridge constitute the compositional nucleus of the scene. Seeing activity around the barges, and expecting that they would soon depart, I made the quick study seen above and incorporated it into the final drawing at the right. In the rendering of these barges, it was urgent to depict them with the darkest tones the pencil is capable of producing. Obviously, this task is the work of very soft leads. The paper was Alexis, a surface with just enough tooth to accept very dark values. In contrast to these darks, the tone which represents the bridge's façade (under the balustrade) was kept very light—just dark enough to display the lighter values of the balustrade and the gracefully arched member that appears to support the bridge. The patch of very light pavement stones bordering the canal prevents the canal edge from leading the viewer's attention out of the picture at the right. Perhaps the indication of buildings beyond the canal might have been extended more completely, yet they are of little more than environmental use, without any architectural interest.

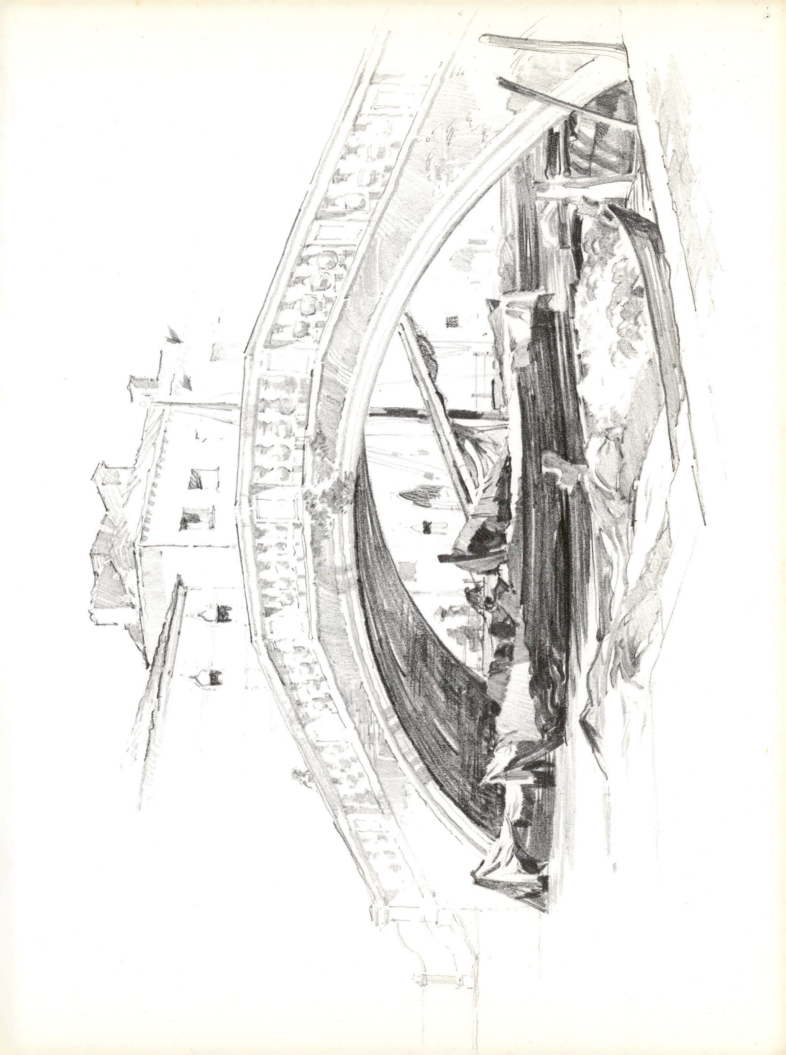

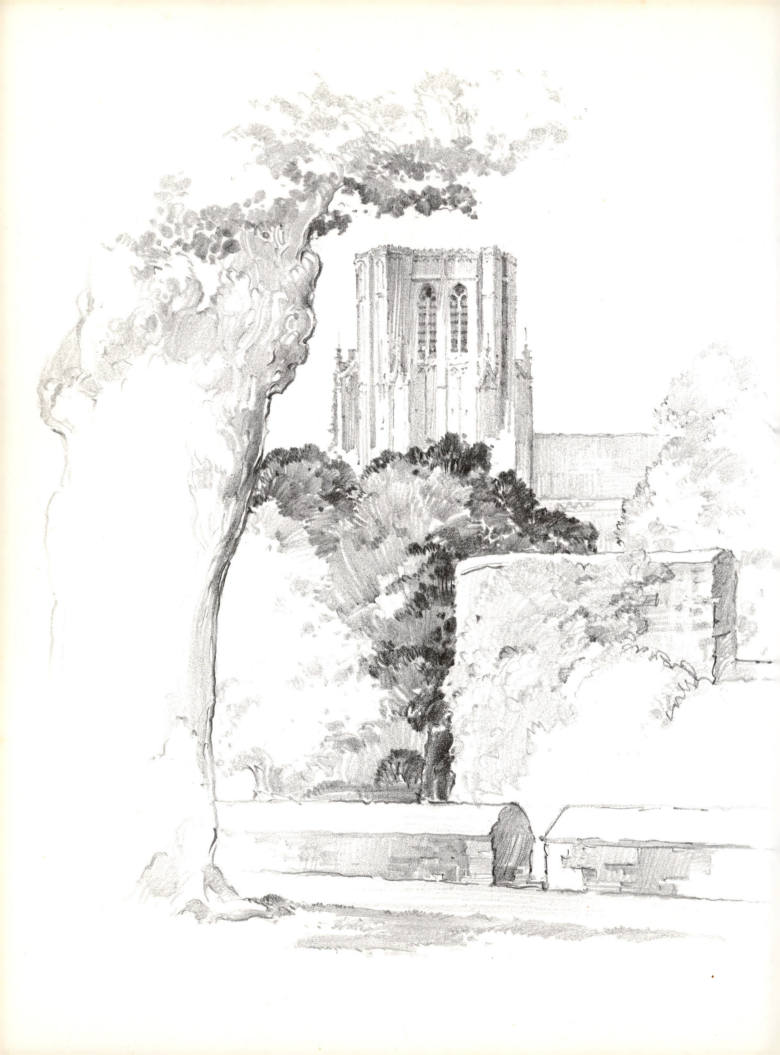

how I might have developed the subject had I been able to draw it on the spot. Note how the darkened building mass on the right gradually is dissolved as it approaches the roof, receding from the center of interest; and how, with restrained suggestions, the now lighted building facades have been given a sense of completion. The light gray shading at the far end helps to focus the light behind the team where we want it. The photograph and drawing of the *Theatre of Marcellus* (Figures 17 and 18) in Rome present a similar situation.

In Venice, the artist is literally surfeited with sketchable subjects. One is bewildered by the beauty which lies before him in the architecture of buildings; the splendor of its bridges, that span the myriad canals; its sculptured forms; and the pervading sublimity of man's commitment to artistry in every detail of environment. This dedication to the arts is the glory of all Europe, but Venice, the "Pearl of the Adriatic," has a special kind of bewitchment for the artist who is confronted with the perfect subject at the turning of every corner. The problem is one of selection, especially if one's time is limited and the desire to draw or paint everything is distracting.

One comes upon some subjects that are utterly compelling. Such was the *Ponte S. Lorenzo* (Figure 20). I say "was" because at that particular time when I first saw it, freight barges were tied up under the span. Those barges were the dark shapely masses that *made* this sketch. I began to draw them at once (Figure 19), ignoring the structure of the bridge, because, seeing considerable activity on the barges, I suspected that they were about to be moved—as indeed they were. I had scarcely finished drawing the boats when two boatmen with poles pushed them out into the canal and out of the picture entirely. This did not disturb me because the bridge remained and, I suspect, looks exactly the same many years later. I took my time drawing the bridge and indicating the buildings on the far side of the canal.

ISOLATING A CORE OF INTEREST

In pencil sketching, simplification is a necessity because one does not reproduce the entirety of any subject in a photographic manner. Always there is a core of interest which one wishes to isolate to some degree from its environment.

Figure 21. Wells Cathedral Tower

This is one of the many drawings I made in that lovely Somerset cathedral town. I carefully selected a view of the tower that would display its upper reaches. It is framed at the left by the old tree, and supported below by a mass of dark foliage. As in all architectural subjects, I drew the tower meticulously, keeping its shadow tones in a silvery middle gray. Although drawn with architectural accuracy, the shadow strokes are vigorous and direct, avoiding the fussiness and monotony of an unbroken technique. I wanted to attract as little attention as possible to the tree, so that it would not divert attention from the tower. The dark foliage below the tower serves as a color contrast, thus enhancing the natural delicacy of the tower. I kept the foliage mass as restricted in area as possible, completing its form below merely by white space with hints of its growth form. The light-toned tree delicately rendered at the right is very important as an enclosing element.

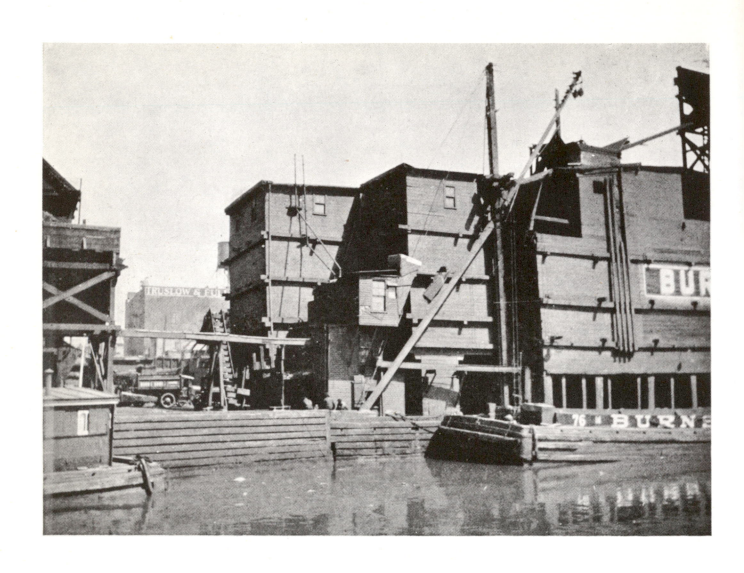

Figures 22 and 23. Photograph and Drawing of Brooklyn Coal Sheds

This drawing, made in 1946 and reproduced in a book now out of print, is useful in illustrating a kind of compositional strategy that has wide application. I refer to the way in which interest is focused at a central point by arbitrarily manipulating the shadows of the projecting coal sheds. These shaded sides of the structure appear in the photograph as uniform values (above). I modified these shadow tones in my drawing (right), emphasizing dark and light contrasts and concentrating the darkest values near the picture's center, which is the natural focal point. Interest is also concentrated at this point by the variety of detail. Notice the introduction of white elements, such as the flight of stairs, at the focal point. The shadowy tone that plays up the side of the pier is not actually a shadow; it is a tonal improvisation, a part of the all over compositional strategy.

44

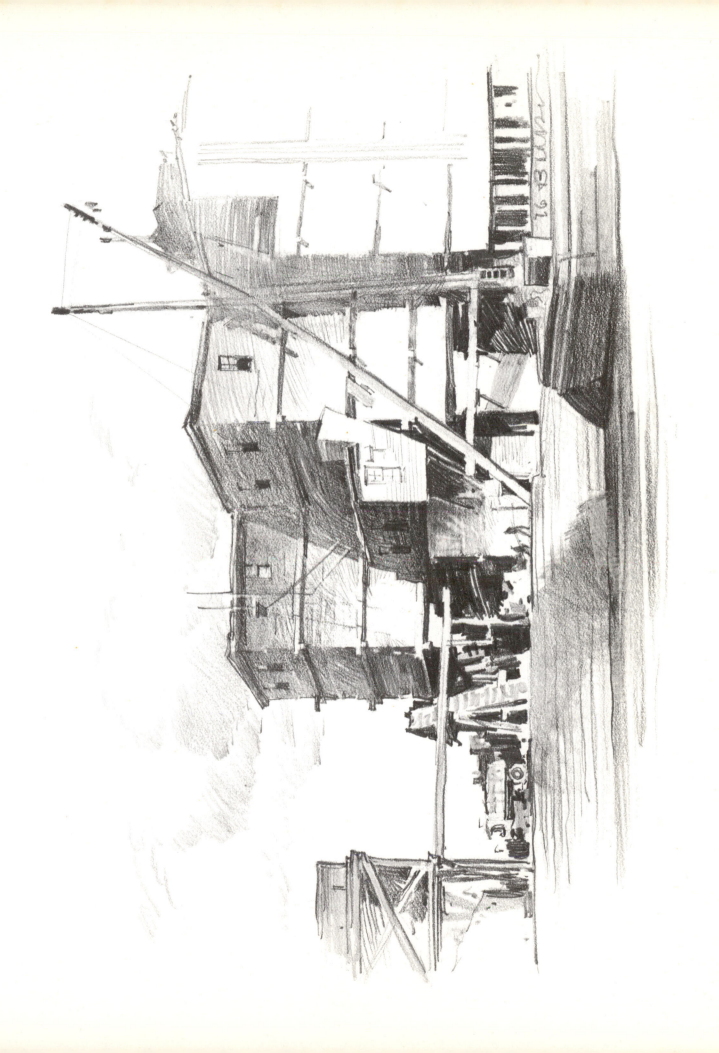

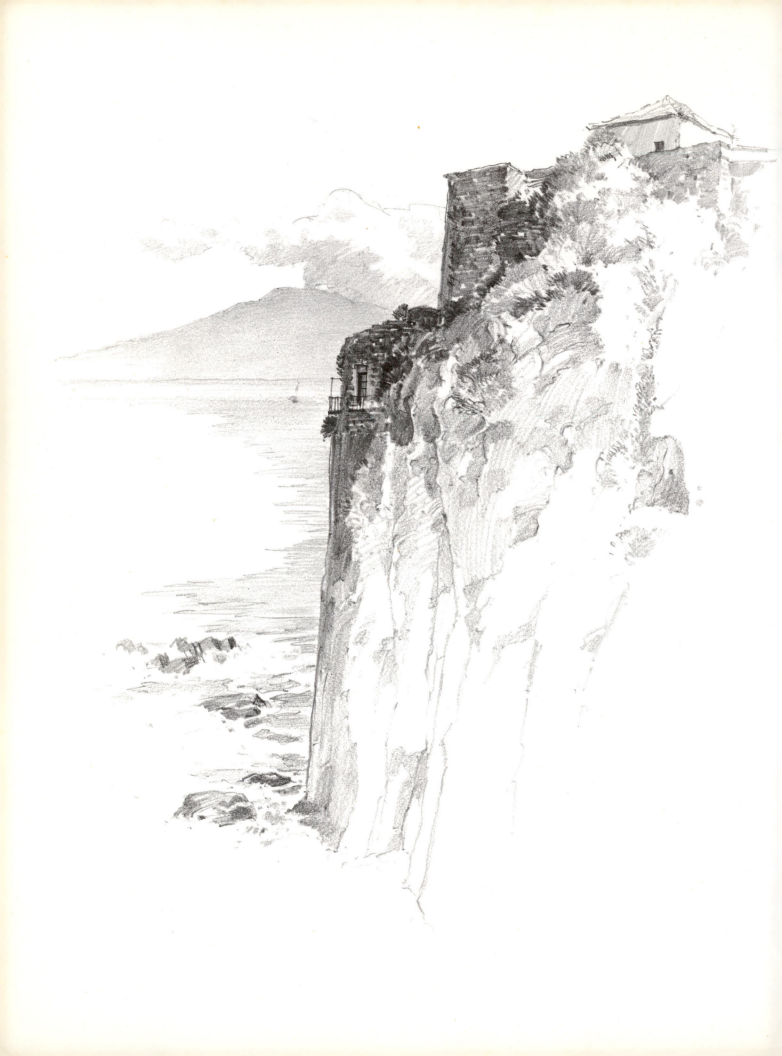

Such, for example, was the *Wells Cathedral Tower* (Figure 21) that rises above a group of trees and a vine covered wall when seen from the viewpoint of my drawing. The tower is the jewel in a setting which should be treated in such a manner as to focus interest upon it agreeably, without allowing the setting to absorb too much of the viewer's attention. So the foliage mass was rendered with restraint, very dark against the structure and merely suggested below. Likewise, the tree that fans out about the tower provides an enclosing frame for it on that side, and the lightly indicated trees on the right serve a similar purpose on that side. The wall that runs along the path below is a supporting base for all.

The drawing of *Brooklyn Coal Sheds* (Figure 23) is accompanied by a photograph of the subject (Figure 22) to illustrate how a drab scene can be brought to life by concentration of attention at a focal point, where interest is aroused by arbitrary manipulation of values and, shall we say, theatrical lighting. In doing this, far from doing violence to natural vision, we are aiding it in what it seeks to do: focus attention upon a restricted area of interest.

It is helpful to remember this phenomenon of seeing—the inability of the eye to focus upon more than a very small point at one time. We cannot "take in" a whole scene, or a picture of a scene, at a glance. People are not aware of this limitation because the focal beam moves over a scene so rapidly, flitting unconsciously from point to point, that the phenomenon is not noticed. The artist is well aware of it and he composes his picture, be it a painting or a sketch, in such a way as to direct attention to a chosen center of interest, and to prevent the eye from roaming indiscriminately from point to point over the entire field of vision.

This purpose was accomplished in the sketch of *Brooklyn Coal Sheds* (Figure 23), by lightening all peripheral shadow values, by concentrating the darkest shadow values in a restricted area at the center, and by throwing theatrical lighting upon the area of action, thus bringing to life what, in the photograph, as in the scene itself, is drab monotony.

Figures of workers have been introduced, and miscellaneous white shapes and lines have been cut into the dark shadow to enliven the sense of activity. The spot-

Figure 24. Vesuvius from Sorrento Cliffs

In this drawing, it was rather difficult to give the effect of the smoking volcano in the distance, while rendering just enough of the immediate foreground to illustrate the dramatic form of the limestone cliffs rising from the Bay of Naples—and to have them serve as a frame or foil for the volcano. It would be impossible to correctly represent the tone of the volcano in pencil. I might better have rendered it in outline. In my sketch, the volcano appears nearer than the fifteen miles away it actually is. Nevertheless, the purpose of the sketch was accomplished, since no one expects the same degree of literalness from a pencil drawing as from a painting in which a far greater range of values—in addition to color—is possible. The indication of the cliffs, accomplished with little effort, is reasonably successful. I added a hint of the shoreline, and a few projecting rocks.

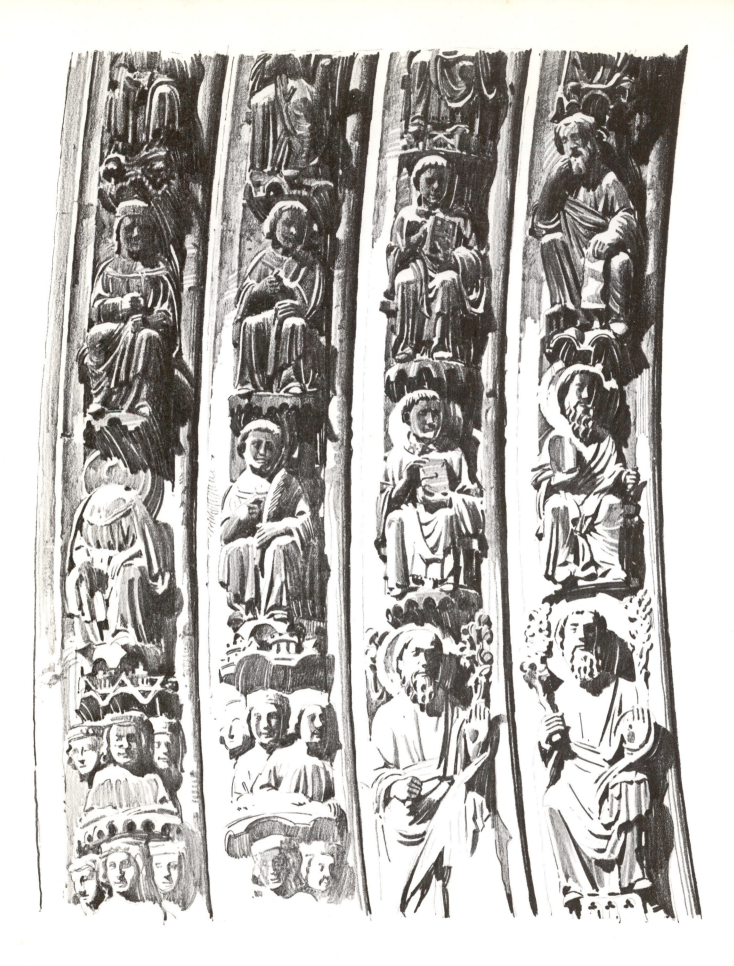

light has brought the flight of stairs out of the shadows. The slanting, shadow-like tone across the pier—which could not have been there—is an arbitrary contribution to the dramatic effect.

VARIOUS WAYS OF MANIPULATING VALUES

Another quite different situation might appropriately be included in this chapter. The panoramic view of *Vesuvius from the Sorrento Cliffs* (Figure 24) was sketched from the garden of the Cocumela pension, perched atop the limestone cliffs abutting the Gulf of Naples. My view was along the side of those cliffs, which rise about one hundred sixty feet or more above the sea, and was intercepted by a prominence known as Montechiaro. This prominence serves as a frame for the view of Vesuvius across the Bay of Naples. I wanted to render this rocky mass in dark tones and then gradually lighten it as it receded from the prominence, at the same time indicating the cliff formation with as little penciled tone as possible.

One would seem to have little scope for composition in the drawing of the ogive, main entrance to Notre Dame Cathedral (Figure 25). Selection would appear to be involved here. It was necessary to select areas to receive an approximation of the tonal *darks* and those in which the detail is brought out into the *light*, tone being restricted to that which was essential for the expression of forms. This arbitrary division of dark and light sections of the sculptured decoration resulted, I think, in a more striking presentation in the pencil rendering than in the photograph itself. The white is carried up with the dark areas by representing the lightest modeling in *white,* instead of the literal gray light of the subject.

Figure 25. Detail of Ogive Sculptures, Notre Dame Cathedral, Paris

The unknown creator of this magnificent sculpture is among the vast company of artists who, during the era of cathedral building, contributed anonymously to a great collaborative achievement for the glory of God. This drawing was made from a photograph. I could not have been favored with a vantage point from which to make such a detailed rendering. Photographs are not likely to evoke the emotional incentive experienced in direct drawing from the subject. Occasionally, however, I have been so stimulated by unusually fine photographs of sculpture and architectural details, that I could not resist the temptation to draw them. One can readily see that my drawing is not a copy. It is a simplification and translation from one medium into another. The forms, but not the tonality, are copied. Tone is interrupted even in the darkened upper area by white paper accents.

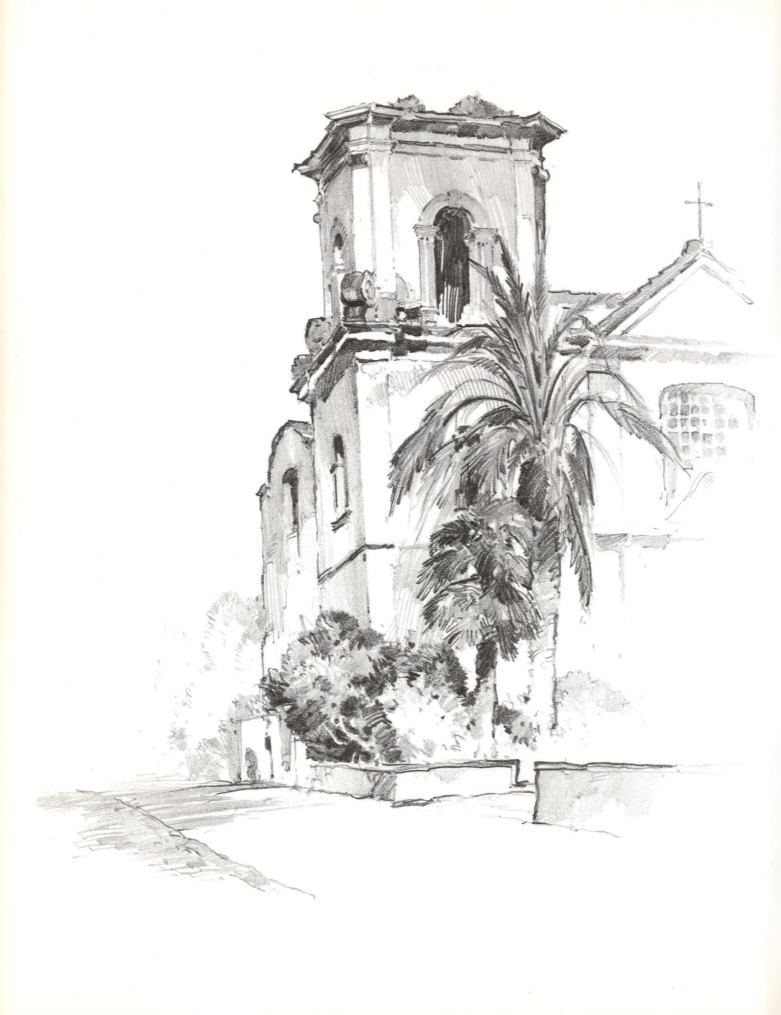

Unless a drawing is being made exclusively with line—without tonal mass, that is—pattern becomes the essence of its structure. Even in line, we do not escape the demand of pattern, as may be simply demonstrated by the comparison of Figures 27A and 27B. In A, the drawing suffers from the absence of design interest provided in B, where the massing of twigs in three different places provides a degree of excitement entirely lacking in A. Thus, tonal pattern is created through the conjunction of lines.

WHAT CREATES PATTERN?

You might say that you cannot make any drawing without pattern of some kind. In a drawing of any two adjacent lines, the shape of the space they enclose, and indeed the conformation of the lines themselves, constitute pattern. In this chapter, however, I refer principally to pattern resulting from relationships of tonal masses —their relative sizes and shapes, together with the white areas that are associated with them.

Color may be almost entirely responsible for pattern possibilities, as in my sketch *Along the Beach, St. Ives* (Figure 28), where the color tones of vines which decorate the wall of the principal building, and the color tones of the roofs, constitute the essence of pattern interest. In such a situation, the designing of the foliage becomes the key to the interest of the entire sketch. Here the mass of the vine is broken into by uncovered areas of the masonry—white paper. The effect may or may not have been just as I rendered it. That does not matter. The tonal variations of this foliage mass—dark and light—are of importance too, and one is impressed by the relationship of nearly black areas at the left to the light tones at the right, where the observer's interest is being gently led out of the picture.

Interesting value relationships are always a big factor in the creation of pattern. Consider, for example, the impact of the black accents of the windows in *Along the Beach, St. Ives*. These are as vital to pattern interest as seasoning is to food. In this sketch, also do not overlook the function of line both in line *width* and line *value*, in its assertiveness and in its expression of perspective.

Figure 26. Old Jesuit Church in Sorrento, Italy

The point of interest in this sketch is the bell tower, where I concentrated my delineation of details. The palm tree is fortuitously placed to support the tower; and the shrubbery at the base serves as a terminating connection with the street.

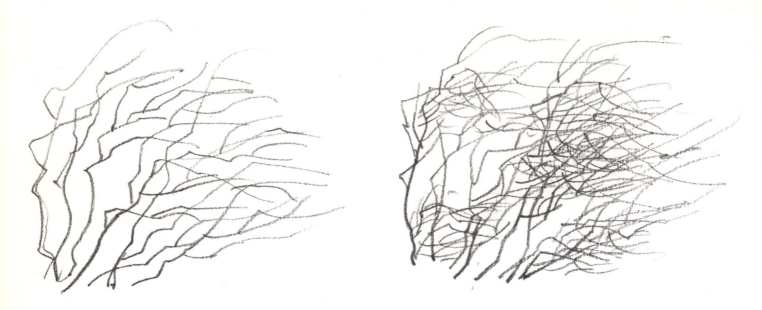

Figure 27. Two Line Drawings of Twigs

Even in line we do not escape the demand of pattern as a comparison of these two line drawings reveals. Drawing A (left) lacks the design interest generated in Drawing B (right), where the massing of twigs in three different areas creates visual excitement.

BEGINNING WITH PATTERN

Pattern is the very first consideration in the creation of almost every sketch. Analyze, for example, the sketch of *Rocky Shore #3* (Figure 29). First we look for the essential, basic pattern which will hold the entire structure together (Figure 30A). Next (Figure 30B), we attend to the prominent secondary pattern details and intend to keep these inviolate, proceeding to subdivide them without losing their identity and their importance in the allover pattern scheme. In Figure 30C, we work within the lighted area of the principal boulder, again seeking the most dominant shapes. After that, we get down to rendering. We have established the framework, but that, however important, is only the beginning.

As we explore the tonal aspects, we get even deeper into pattern problems. Yet, if we have become expert and have "taught our pencil," it takes over very much as I have tried to illustrate in the detail of *Rocky Shore #3* (Figure 31). Within that small shadow area, pattern continues to dominate our work. And pattern here, as you see, is involved with values and with technical niceties, where direction and character of stroke conspire with white (or light) accents within the mass to portray the texture of the rock and to create an agreeable abstract expression.

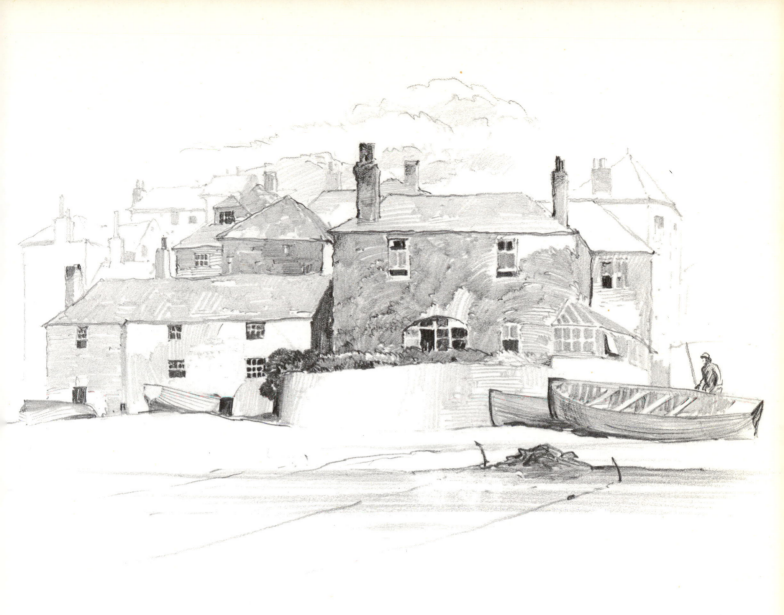

Figure 28. Along the Beach, St. Ives, Cornwall

On the shore of almost any harbor in Cornwall, the artist is treated to the delights of ancient towns created to serve the business that for centuries has been the occupation of this part of old England—the sea. I made many drawings in St. Ives, Mousehole, Newlyn, and other Cornwall harbor towns—seaports that have been sketched and painted by thousands of artists. The typical group of masonry structures seen here is not perhaps dramatic in itself, but, rather, colorful by its informality and meaningful presence. Pattern and value relationships dominate the vine which clings to the main building of this group. How vital to the effect are the two uncovered areas of the wall and the contrasting dark window openings. Note the variety of tone in the greenery, graduating from the near black foliage mass that creeps over the wall, to the very light areas at the right, where solid tone gives way to open-line technique as interest trails off for exit at the right. The dark mass of seaweed near the boats contributes an important balancing tonal note, and adds an appropriate illustrative accessory as well.

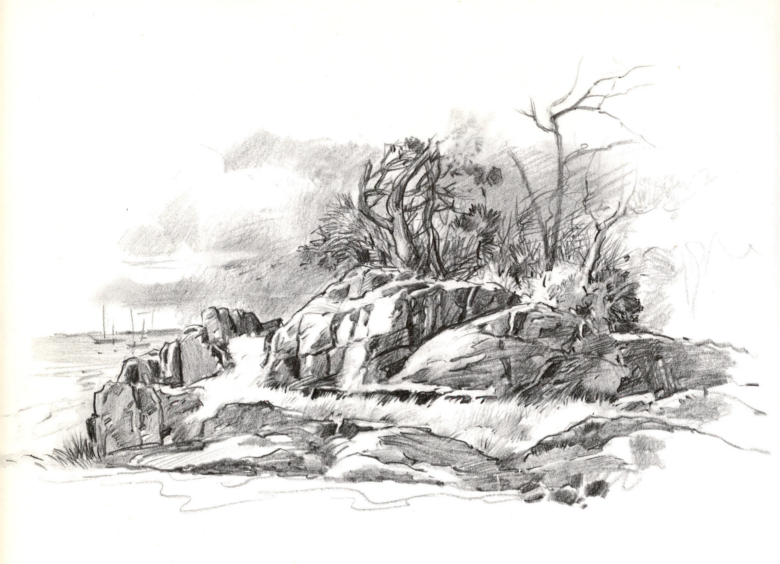

Figure 29. Rocky Shore #3, Larchmont, New York

This is one of several studies I made of the interesting rock formations on the New York shore of Long Island Sound. The rocky outcrops attract geologists and artists alike. A comparison of the three studies discloses different rendering techniques, which are due, in large measure, to the drawing papers on which I worked. The two other rock subjects (Figures 32 and 34) were drawn on clay coated paper, which not only permitted scraping out of white shapes and accents, but also provided diversity of tonal character. However, there is considerable technical interest in the toned areas. If this rendering lacks some of the tonal character apparent in the other interpretations of the same subject, it emphasizes the pattern structure, as is pointed up in the accompanying analytical diagrams.

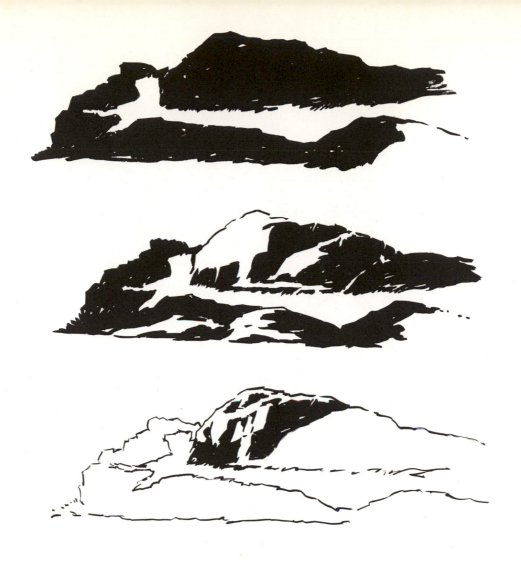

Figures 30 and 31. Pattern Structure of Rocky Shore #3

Figure 30A (top) isolates the dominant compositional basis of the picture—what I call the anchor pattern. In 30B (center), the secondary pattern units appear. And in 30C (bottom), these secondary pattern units are subdivided into smaller light and shadow details. Figure 31 (below), a pencil sketch, explores a detail of the same subject. Within that small shadow area, pattern continues to dominate, involving itself with values and technical niceties.

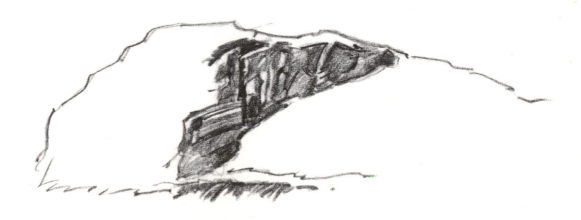

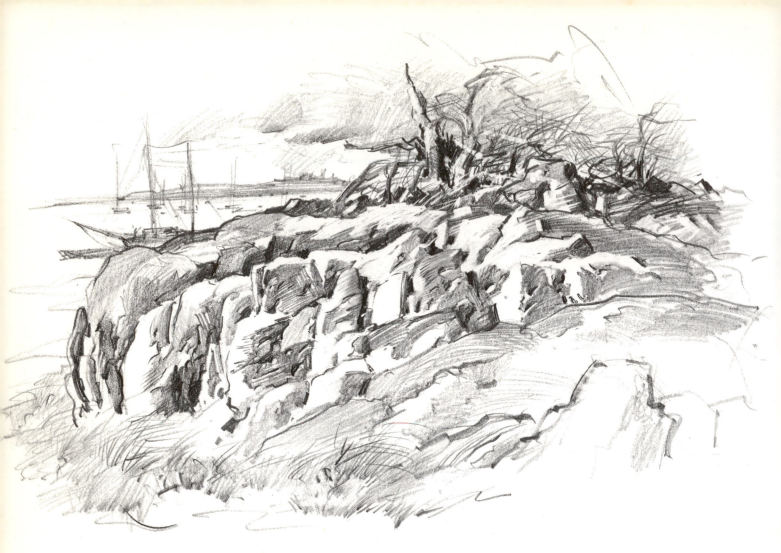

Figures 32 and 33. Rocks at Shore, Manor Park, Larchmont, New York

In contrast to the simple compositional arrangement of Rocky Shore #3 (Figure 29), the light and dark shadow patterns of this rock mass might be described as jazzy. The drawing is composed of many small, dark and light areas which keep the eye bouncing from one detail to another. The line analysis (Figure 33) explores the dominant divisions of the rock formation. The nearer rock mass forms a distinct unit silhouetted against the enfolding rocks behind. I remember insisting upon the cohesion of this group. The dark massing of clouds, cohering with the tree mass, is a stabilizing factor in the design.

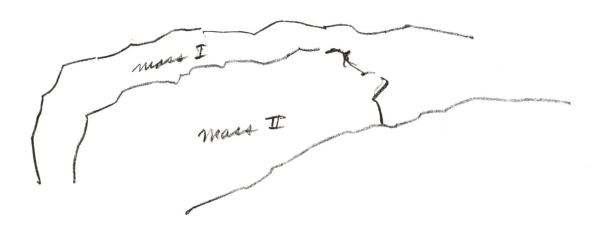

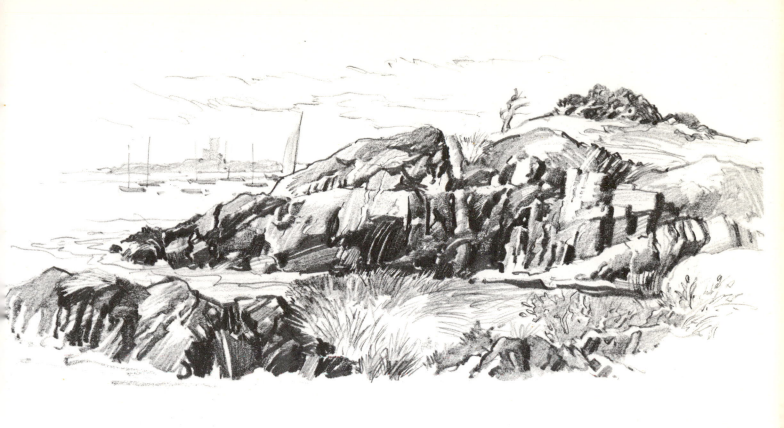

Figures 34. Rocks in Larchmont Harbor

I consider this my best drawing of rocks—and I've made many of them. The subject itself was fascinating, and I sketched it at just the right time of day, when the light revealed the beauty of these boulders. All I had to do was follow my pencil. The niceties of technical rendering were spontaneous and effortless. The drawing is on clay coated paper, so it was probably rendered with two or three leads. The treatment is so direct that I did not need to take advantage of the paper's scraping out possibilities. On a clay coated paper like Video, one can create the blackest tones of which any pencil is capable. The intrusion of white accents throughout adds immeasurable sparkle to this sketch. The sky needed only the barest linear cloud indication. Indeed, as you examine most of my drawings, you will note that the sky seldom goes beyond line suggestion. It is not often that I venture into tonal modeling of clouds. Usually, white paper with a few linear cloud suggestions suffices. Though tone does most of the work in this drawing, line accenting of contours is very important. Collection, Mrs. Frederic C. Michel.

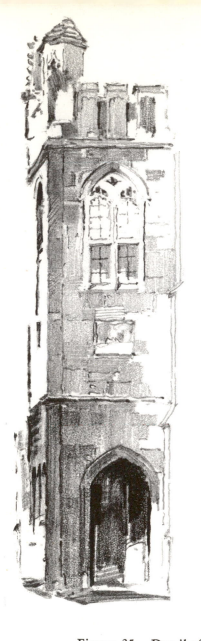

Figure 35. Detail of the Chain Gate, Wells Cathedral

The tonal patterning on the narrow wall is a typical technique used for rendering masonry. The white shapes which break into the tonal mass serve a two-fold purpose: they create pattern, and they act as a transition to the adjacent wall. Note the diversity of values within the individual stones—a purely arbitary variation of tonal reality.

Figure 36. A Canal in Venice

Sauntering along the canals of Venice, one comes upon dramatic compositional effects that vary with the time of day. At a time other than that chosen for this sketch, the light and dark effect of this scene would be quite different. The sunlit wall would be in shadow, and the impact of that dark shadow missing. Here I solved the problem of leading into or retreating from the sketch by creating an arbitrary pattern in my treatment of the paving stones. Reference might also be made to the wall of the distant building, which combines an area of smooth tone with sharply pointed pencil strokes above. There was no need to indicate the structural composition of the wall as I did in the narrow vertical wall at the end of the walk. Here the indication of a few blocks of stone within a broad tonal mass (which tapers off to white paper) suffices to give an impression of solid structure. Collection and courtesy, Mr. Donald Holden.

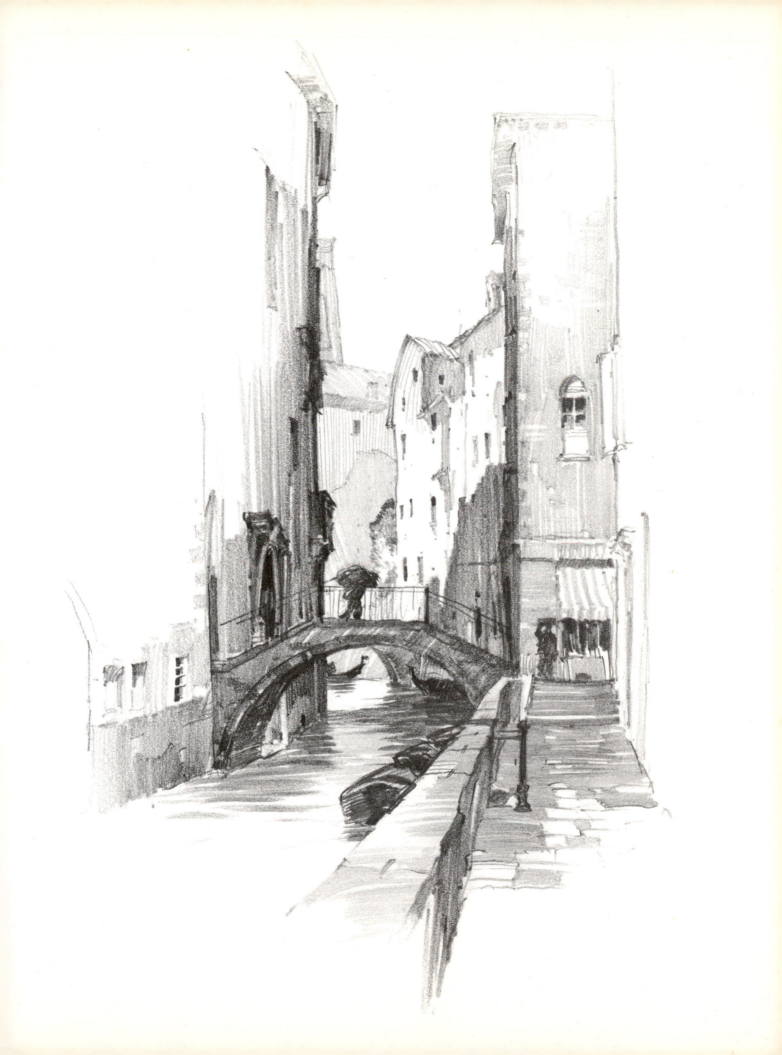

Now study other drawings as you contemplate the ways in which pattern operates. Compare the other rock studies (there are three in the book) in Figures 32 and 34. In these, the basic pattern structure may not be so obvious. In Figure 32 you will have to search for it. Figure 32 indicates two main divisions in the rock masses which I was constantly aware of as I drew. I call this drawing a jazzy rendering, being so intrigued with the jumble of broken elements. But look herein for the kind of pattern effects I've pointed out in Figure 31.

PATTERN IN MASONRY

I now call attention to a kind of patterning we commonly use in rendering masonry. I isolate a detail (Figure 35) from the drawing of *The Chain Gate, Wells Cathedral* (Figure 9). I have already written at some length about various technical aspects of this drawing, but I want to refer here to the tonal patterning upon the narrow wall that is isolated.

We have, first, the intrusion of white stone shapes which break into the tonal mass. These white shapes not only create pattern, they also serve as an agreeable transition to the adjacent wall, which is indicated only in outline. This avoids an emphatic and undesirable separation of the two walls. Then, looking within the tones themselves, we note great diversity of values in individual stone members— some dark, some light—a purely arbitrary variation of tonal reality. All presumably were of equal value.

This effect of patterning of masonry structure is evident in many of the drawings, among which I shall point out one other: the paving of the sidewalk in *A Canal in Venice* (Figure 36).

BASING COMPOSITION ON PATTERN

Now to come to a consideration of pattern which becomes the structural basis for the whole composition of the sketch.

To illustrate this, I refer to my sketch of *St. Germain, France* (Figure 37). With it I show an analysis (Figure 38), in a rough sketch, which I have made to illustrate how a drawing develops upon a positive and felicitous pattern which is

Figures 37 and 38. St. Germain, France

The little pattern sketch (right) was done in a minute or two, as a preliminary for the drawing of St. Germain. In it, I organized the design, planned the values, and simplified the tonal scheme. In starting the drawing itself (above), I began with the black notes under the awnings, then rendered the dark shaded sides of the buildings and the cast shadow. The roofs came next, then the lightest tones. Last, I drew in the clouds and the curb.

visualized *before* any drawing is begun. I happened upon this scene at a very opportune time. The tall buildings at the left were casting a dramatic shadow upon those on the opposite side of the street. Had the day been cloudy and the scene devoid of this ready made skeleton pattern, I would have been obliged to create my own. In any event, I would not have left this place without a sketch, which, by the way, is dated by the horse drawn carts. It was made in 1925.

A similar pattern situation is seen in the sketch and pattern analysis of *Old Swiss Chalet, Zermatt* (Figures 39 and 40), which were made on one of the few brilliant days I spent in that stimulating town.

In *A View of Zermatt* (Figure 41), there is no unifying pattern of dark and light; the sketch is nothing more than a factual record of a scene I wished to remember because of the hotel where I put up during my visit there, and to remind me of the rather tortuous approach among the small houses of monotonous similarity. I have included it as an example of the *failure* to produce an exciting drawing without strong pattern interest. On many occasions, we make purely factual drawings of things that we thus want to remember.

PATTERN AND SILHOUETTE

Pattern, of course, applies to silhouettes, their shapes, and their contour characteristics. Refer to the tree silhouettes (Figure 82). The pattern of these trees, so different from one another in form, is the first aspect with which we are concerned. We are attracted to trees which are most appealing in their silhouette patterns, and we are insistent upon correctly portraying their silhouette aspect *before* breaking their masses up into light and shadow definitions.

Often there is little more than a silhouette to be done, especially if the trees are relatively distant in the landscape. But when the trees are viewed at closer range, we have the problem of rendering the details of branch structure and foliage groupings. Often the foliage is confusing in its monotonous repetition of many unrelated details.

Even in rendering distant tree groups—those not near enough for focus upon structural details—there is the need for textural refinement of the masses in a man-

Figures 39 and 40. Old Swiss Chalet, Zermatt

The chalet makes a picturesque subject for any medium. It is a particularly delightful motif for the pencil artist because its construction—deep roof overhang and butt ends of timbers which support the horizontal wall timbers—gives the sketcher something very tangible to get hold of. This sketch was made in a favorable light; the sun was falling directly on the gable end, creating deep shadows of great interest. Actually, the tone of the gable façade was uniform, but the pencil rendering shows great tonal variety, lightening up the façade by the use of white areas, within which the horizontal timbering is indicated by line. The accompanying analysis (Figure 40) explores the confining light and shade pattern of the chalet.

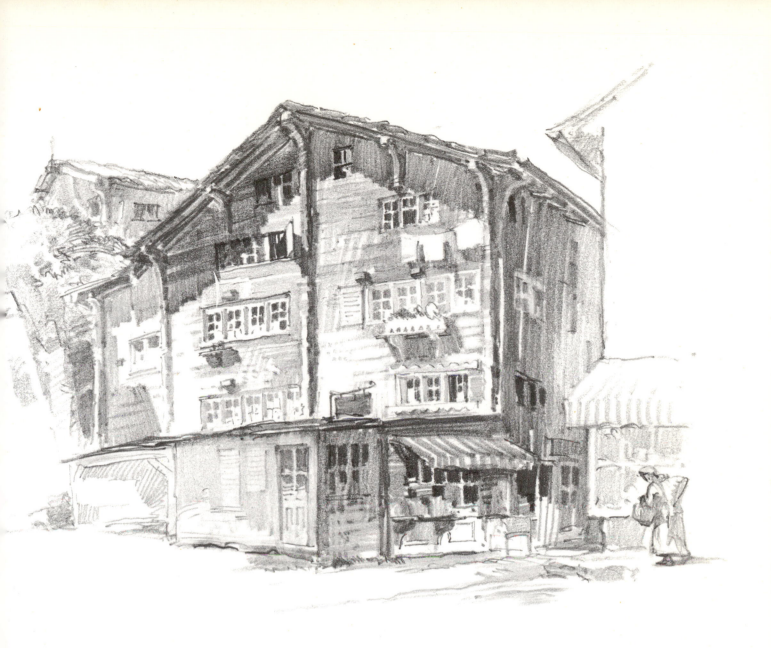

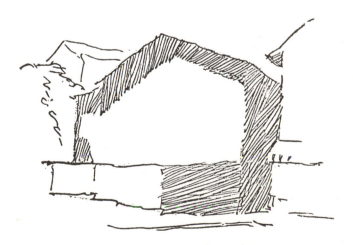

63

Figure 41. A View in Zermatt

This sketch was made principally to record a picture of the hotel where I lived for a few days in 1925. The mountain rising abruptly behind the hotel is dotted with simple huts or chalets. The stream which flows in the foreground seemed as white as milk—the mineral deposits from the surrounding mountains. The crazy cluster of little huts which lines the path to the hotel makes little sense esthetically, so I did not try to make a studied composition of them. This sketch is a realistic report of what was there—no more, no less.

Figure 42. View of Cheddar, England

Cheddar was, years ago when I was there, a sleepy and beautiful one-street town. It was located on a lovely lake, lightly indicated in my sketch, below Cheddar Gorge. Water is always a problem to render in pencil. My usual way of suggesting water is to accent the light tonal strokes with sharp line—as I characteristically did in this sketch. I also call attention to the treatment of the banked trees—the employment here of accenting lines to give a sense of solidity to the mass and to add technical variation. These line accents help give this scumbled sketch more assertiveness. Line accents are used around some of the lighter areas of tone within the tree masses. The tree tones were kept very dark at their bases to contrast dramatically with the buildings silhouetted against them.

ner suggested by my drawing at *Cheddar, England* (Figure 42). There, I did introduce some light and shadow effects and, as you will see, I have added accents with a sharp point and directional lines within the silhouette mass, which serve to give considerable textural and tonal attraction to what might otherwise have been a relatively flat tonal shape.

While referring to that Cheddar sketch, I might speak also of the function of pattern in suggesting water. This combines arbitrary pattern with more than a hint of reflections from the white buildings. I have found that the use of sharp, thin line is helpful in giving the light, tonal water shapes a sharper definition and a more positive statement.

TONE AND VALUE

Lest the term "tone" be confusing to some readers, I should explain that tone (as I use it in my book) should be envisioned as *color tone*, which, according to the dictionary, means the dark or light value of a color. But in speaking of non-color work, I think the term *tone* is generally understood to mean *value*. Tone is more appropriate than value in such use, since value has other connotations not involved in black and white drawing.

In conclusion, I would say that pattern is the artist's first consideration in the analysis of any subject he chooses to draw. It is an anchor for every detail of his drawing. Other shapes are tied to the dominant pattern core. Making rapid analytical pattern aspects of any subject—similar to those I made for the *St. Germain* drawing (Figure 37)—is certainly good practice, at least until the time when such an analysis can be purely visual—in the artist's head, rather than sketched out.

Figure 43. Another Swiss Chalet, Zermatt

The darkened passageway between the buildings, which leads upward and includes the steps, establishes the tonal key for all the other gray areas which focus upon it. This tonal scale is conspicuous in the shadow of the roof overhang, which tapers from very dark to very light at the right; and it is true of all the tones on the facing façade that gradually lighten in value as they recede from the central interest. The principal stroke emphasis on the building, like the timbers themselves, is horizontal. Monotony is avoided by vertical strokes which offer contrast, but are not insistent enough to destroy the horizontal structural characteristic. Distant hills or mountains are difficult to indicate with the pencil. Should one use tone, or merely line, to suggest them?

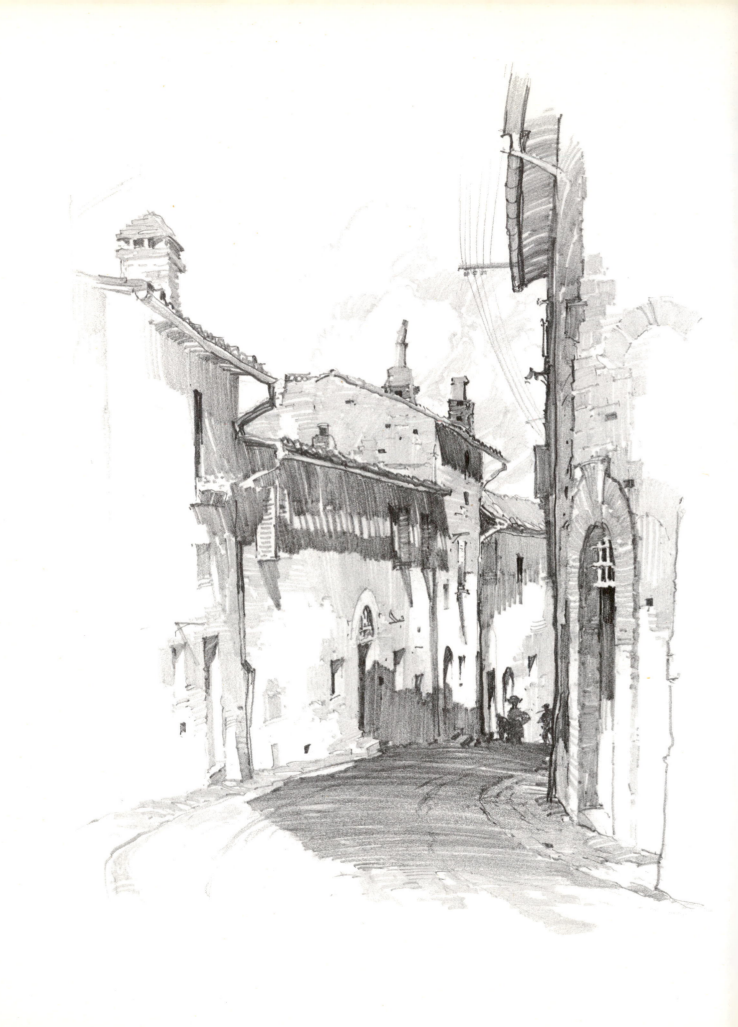

I have never lost my wonder at shadows. As I write this morning, near noon, I sit in our garden, which is enclosed on one side by an exquisite wall of clinker brick built by an Italian craftsman whom I should love to meet. In the wall, set in an arched recess, is a beautiful sculptured head. It is a copy of an original Mayan head. Now, at this moment, the early October sun brings it to life. It casts a delightful shadow that falls upon the unevenness of the textured wall. Overhead, the ivy vine that drapes the wall hangs slightly over the arched curve of the recess and adds its serrated shadow to that of the sculpture. Sometimes it seems we are vouchsafed an unexpected awareness of the beauty of simple things. This has been one of those moments when, in meditation, I recall the words of William Saroyan, quoted in Chapter 2. Read them again. At the first reading you may have overlooked their profundity, perhaps considering them no more than a poetic reference to a common experience rather than a practical prescription—as indeed they are.

Shadow may be wholly responsible, or practically so, for the pattern seen in many sketches. A perfect example of such dominant and illustrative pattern is seen in the tonal analysis of my *Mousehole* sketch (Figure 49). Shadows almost always define much of the subjects' forms and are the basis of pattern in perhaps the majority of sketches.

SHADOWS AND FORM

Shadows are the artist's best friend. Without shadows, form is invisible. Paint an object uniform in color and value, illuminate it so that each of its facets receives an identical amount of light, and it disappears from sight. Form can be described by pure outline—*described*, but not portrayed. There are no outlines in appearance, though outline has a useful and an esthetic function in representation to which we have been conditioned from childhood—when we began to draw in outline.

Figure 44. Assisi Street

I have included a number of Assisi street sketches because of their unusual architectural interest. This sketch was made when the sun played upon the buildings with a delightful tonal consonance, which left little need for improvisation in designing the shadow pattern. The tones of the foreground, which lead the eye to the center of interest, are the only exception. Note the arbitrary patterning of gray and white on the sunlit walls. The figures at the street's end serve as tonal accents, and give a feeling of aliveness to the scene.

Shadows cast by forms and their details in turn define the character of the forms themselves. Hence, the artist insists upon the relative accuracy of their shapes as they appear in nature. Shadows cast by invisible forms (hence of no descriptive importance) can be treated arbitrarily and used to best advantage in the compositional pattern of light and dark as one sees fit. Such is the case in the *Assissi Street* (Figure 44) and in the sketch of a Venetian canal (Figure 45). In both of these scenes the shadows upon sunlit walls give no hint of the shapes which cast them, so the artist is free to manipulate them esthetically, without obligation to objective reality.

Sometimes, however, the cast shadow is controlled by the nature of the surface upon which it falls. In these two drawings, the surfaces were practically plain walls.

ACCENTING SHADOWS

There is a different situation in my sketch of the *Rialto in Venice* (Figure 46). In this case, the shadow on the near end of the bridge has a descriptive function; it defines the sculptured convolutions of this structure that spans the Grand Canal. This shadow is the most important feature of the entire drawing. I chose carefully the time of day when it appeared just as you see it in my sketch.

Notice that this shadow is darkened at its delineating edge. And in examining other drawings you will observe the same treatment of shadows. It is common practice. This effect, which may or may not be present in nature, depends upon the lighting and the reflected lights that often condition the shadows greatly. But shadows thus rendered with emphasis on the edge give the sketch a positive character and enliven its general aspect. Even if the shadow is not assertive in the subject, it has an enlivening effect because of the contrast with lighted areas where shadows fall.

The accenting of shadows at their edges is an important aspect of the drawing of a mountain peak near Gates Pass in Tucson, Arizona (Figure 47). It is evident that here, where exact delineation is really not as important as it is in architectural subjects, the accenting of shadows (even by linear accents) is an important technical device. The emphasis at the shadow's edge is easy to render because, when drawing vigorously, you naturally end with a degree of accent of the strokes— which presumably is at the shadow's edge.

Figure 45. A Canal in Venice

At almost any time on a sunny day, sun and shadow effects give Venice's canals very dramatic picture effects. The artist can play with the shadows to suit his pictoral needs. My sketch is probably fairly faithful to the shadow pattern that drew me to this particular subject. The shadow that plays upon the building facade at the right combines agreeably with the dark bridge and water reflections. I treated the building on the left with as little detail as necessary to give it reality. The sunlit walls of the various buildings needed tonal rendering to give them a sense of structure. These very light tones were laid in with vertical, diagonal, and horizontal strokes.

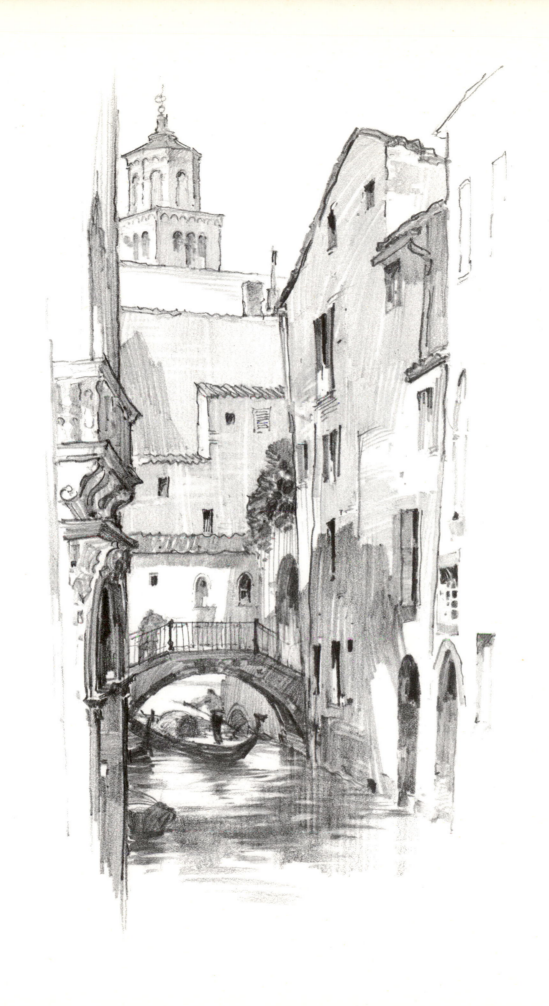

◄ Figure 46. The Rialto, Venice

The original drawing, on Alexis paper, is 9" x 12". Hence the necessity here for a slight reduction in size. I worked somewhat larger than I usually do because the subject seemed to need size to accommodate the great amount of accurate detail I wished to render. I have made special reference in the text to some of the shadow aspects of the drawing. There are other factors which I might mention. In the majority of my sketches, the skies are cloudless; here the slight cloud indication seemed useful as a tonal bridge to connect the two towering architectural masses, and thus contribute to the compositional unity of the drawing. Representation of water is usually puzzling to the student. Where there are shadow reflections, as in this subject, I usually keep the tonal areas as restricted as possible. Here, I evidently felt the need to design the reflections with great definition, and even emphasized their shapes with sharp outlines to give them a positive accompaniment to the architecture.

▲ Figure 47. Near Old Tucson, Arizona

These crumbling peaks present fascinating forms. Note the way the shadows of the details are sharply accented to intensify the projections of the crags which cast them. Consider also the smoother mass of the debris which fans out at the base. This rapid sketch was drawn on Alexis paper with 4B, 2B, and HB leads.

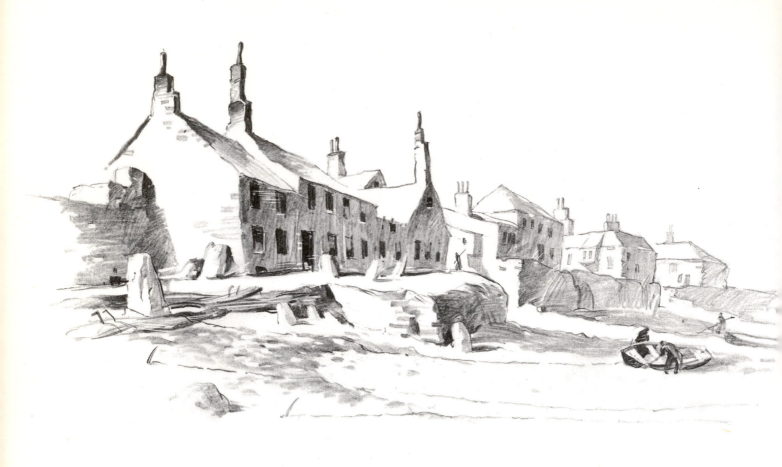

Figure 48. Mousehole, Cornwall, England

One wonders how this quaint little Cornish harbor was christened Mousehole (pronounced mussel). Like other Cornish harbors, its water was impounded at high tide by a stone dyke, whose gate could be opened and closed according to the operational requirements of the fishing fleet. What artist could possibly come upon this scene without recording it? It must have been sketched and painted hundreds—even thousands—of times. Perhaps the first thing to note about my drawing is the near completeness with which the shadows present the essence of the pictorial effect. In the accompanying shadow analysis (Figure 49), as in the original drawing, note how tonal perspective has been manipulated to represent the gradually increasing distance. The boat with the fisherman adds not only an appropriate illustrative detail, but also provides an important balancing dark note.

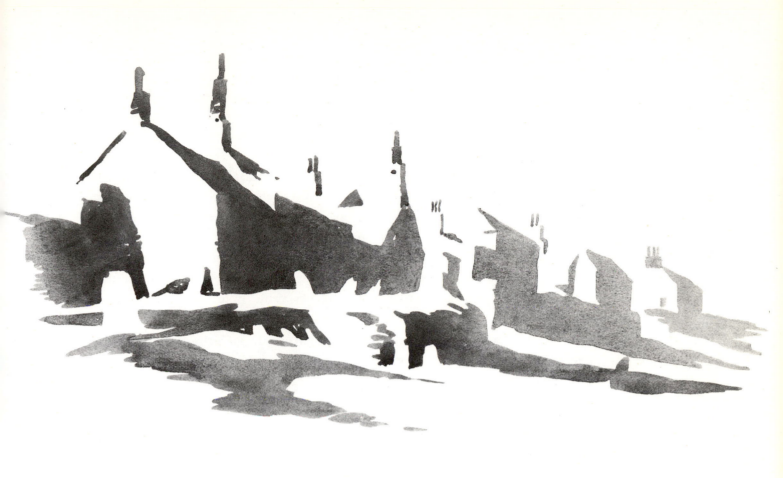

Figure 49. Flat Tone Rendering of Mousehole, Cornwall, England

This tonal analysis of Figure 48 shows the basic light and shadow pattern of the fishermen's houses. Note that the patch of foreground detail (which is very light in the finished sketch) has here been brushed in solidly to emphasize its importance in the over-all design.

CREATIVE MANIPULATION OF SHADOWS

The drawing of the *Brooklyn Coal Sheds* (Figure 22) demonstrates how manipulation of shadows and shadowed areas can become creative, in this instance serving to focus interest at an area of action. Shaded walls in the drawing of *The Chain Gate, Wells Cathedral* (Figure 9) illustrate how the artist can play creatively with pencil tone. Presumably, the facing wall of this structure was about equally shaded in all its parts. In my drawing, tonal values on this wall run the full gamut of light to dark, with darker tones rendered arbitrarily, according to my feeling for strategic compositional effect. Such tonal play of light and dark values affords the artist a most pleasurable opportunity for pattern disposition, and it enlivens the drawing immeasurably. The shaded street in this sketch is creatively fashioned to afford an agreeable entrance into the picture, its value gradually lightened in the immediate foreground where it trails off into a linear pattern.

Sometimes the shadows of a subject reveal its nature in patterns of remarkable completeness. Such is my pencil drawing at the harbor of Mousehole in Cornwall, England (Figure 48). The diagram of this sketch (Figure 49) demonstrates how useful it is to visualize the subject in the simplest possible light and shadow pattern. In this analysis by flat tone, I included some areas which actually do not fit into the shadow pattern—the foreground shape on the near beach, for example. This shape is purely arbitrary. But I translated it into the flat shadow tone to show that every part of a drawing might profitably be thus considered in composing the sketch. In other words, the shape of this arbitrary area was designed as a part of the over-all pattern of the subject. It continues to have this function where its value is extremely light. In my analysis, the shadow tone becomes lighter in value with increasing distance. This, of course, is a natural perspective effect.

It is not often that shadow shapes are as completely revealing of the subject as in this picturesque complex of houses on the harbor's shore, but our demonstration does point to the advisability of looking for shadow simplicity in whatever subject we tackle. As I now write with the pencil drawing and its analysis before me, I have a feeling that I should have been more influenced by this kind of thinking when I was drawing down on the beach. Perhaps my entrancement with the subject led me into too much detail.

Arbitrary shadow patterns often are very useful in adding design interest to a sketch. As an example, I refer to the *Ruins of Glastonbury Abbey* (Figure 60), where an unexplained shadow breaks across the wall at the right of the arched opening. I use this device commonly when I feel the need for more pattern interest at some points. No one knows or cares about the source of such shadows.

In my chapter on trees I shall have more to say about shadows in rendering foliage, where they are supremely important both in defining structure and for technical enhancement.

Figure 50. Abandoned Old Farmhouse, Salisbury, Connecticut

A very casual fifteen-minute sketch of a subject which caught my eye because of the shadows that gave the old buildings a sunny appearance.

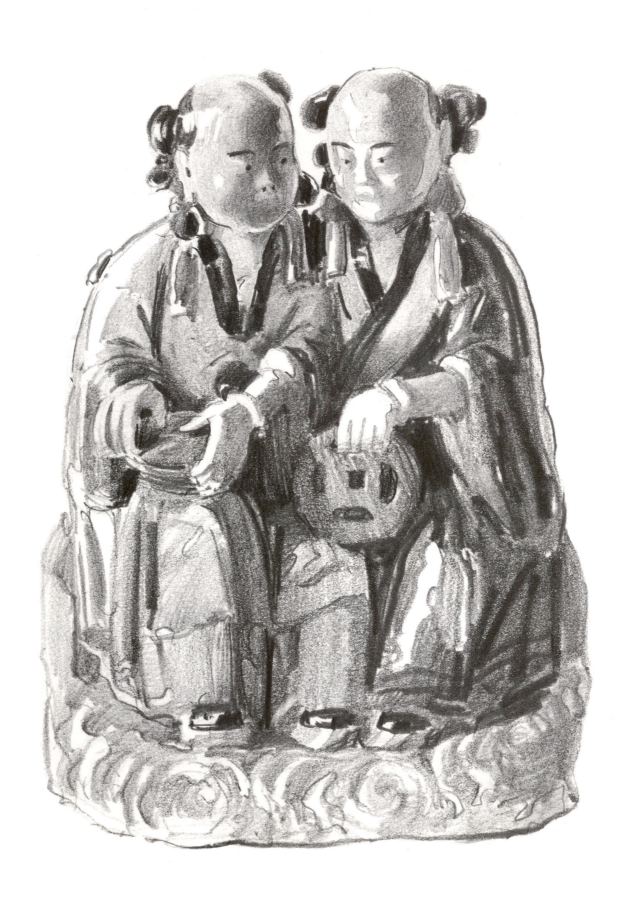

References to texture were made in the chapter *Ways with the Pencil* but the subject deserves further exploration. We also discussed the part played by paper in producing various textures, but some repetition may not be out of order, since the importance of paper in creating texture is so frequently overlooked even by those who have been instructed.

TEXTURE AT CLOSE RANGE

Texture may be thought of as it relates to the imitation of actual textures of the subject, such as the texture of the porcelain of the Chinese figures (Figure 51) and the texture of weathered marble in the columns of the Temple of Zeus (Figure 10). In rendering these subjects, there is a preoccupation with verisimilitude, the expression of material characteristics. Such textural renderings are limited to objects or surfaces seen at close range.

In this category I mention the fascinating textures of trunks and branches of ancient trees, veterans of long wars with the elements and victims of the attrition of the aging process itself. Such, for example, is the dead maple (Figure 52). The textured effects respond beautifully to the special aptitude of the pencil for rendering intimate detail.

PAPER AND TEXTURE

It is obvious that for simulating smooth textures, one should select a surface that is relatively smooth. Yet there are papers on the market that have ultra smooth surfaces that are of no use with graphite pencils. Clay coated papers that feel smooth to the touch actually have considerable tooth, as one can see through a magnifying lens. Yet due to their composition, clay coated papers yield the smoothest of all tones because their tooth breaks down under the pencil when a relatively hard lead is used.

Figure 51. Chinese Porcelain.

Drawn at nearly the exact size of the original at the Brooklyn Museum. Although porcelain has a naturally luminous surface, it is important not to be carried away by highlights which can destroy the form and become distracting. Surprisingly, the glow of these little figures is achieved by rendering them almost entirely in halftones and shadows, with a very limited number of strong, carefully placed highlights which are just white paper.

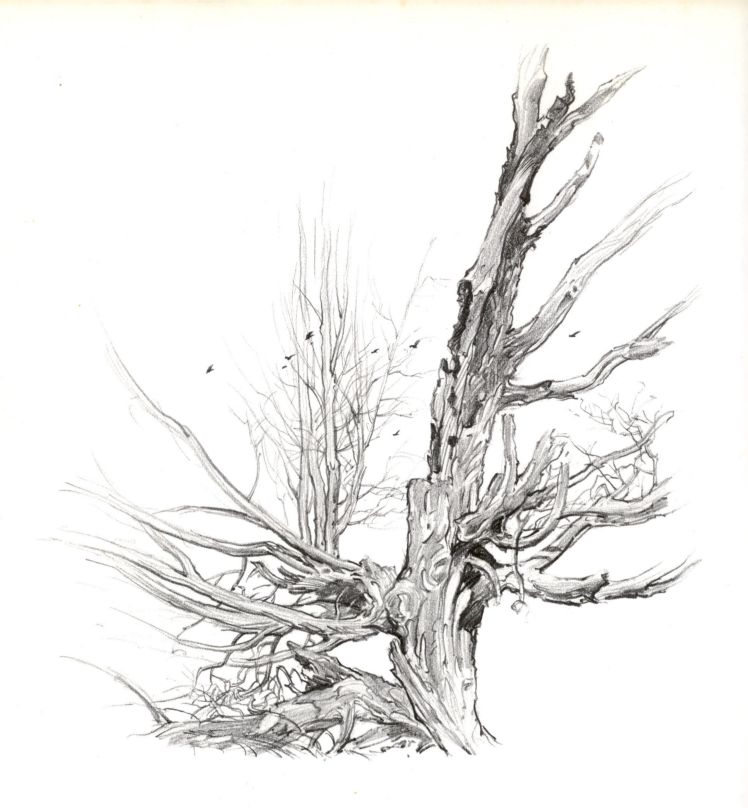

Figure 52. Dead Maple on Vermont Home Farm of My Son Aldren Watson

I was entranced by the beauty of this old tree. The average person, of course, thinks a living specimen more beautiful, and may even be repelled by a dying one. But such a tree presents the greatest beauty in its weird shapes of writhing branches, the textures of its wrinkled bark, the blackened decay here and there, and its variegated patterns. Note the technical virtuosity which combines line in a few areas to give variety to the smoother strokes.

Figure 53. Charlie

I have made many drawings of figures and portraits, but most of these are not in my possession and cannot be secured for reproduction. Therefore, this aspect of my drawing has had to be neglected in this book. However, this portrait of Charlie (a native of the Berkshire Hills in Monterey, Massachusetts, where I had a summer home for many years) will serve to demonstrate how useful the broad-stroke technique can be in figure work when drawing time is limited. Two or three of the softer leads were used, with pointed leads around the eyes for detailed delineation.

PENCIL AND TEXTURE

The drawing of the Chinese porcelain (Figure 51) was rendered many years ago on Alexis paper. The smooth texture of the heads was developed with pointed leads, and possibly lightly blended with the stump. Note that the contours of the highlights and the reflected lights were very sharply defined; the highlights on one of the heads were even dogmatized by an occasional hairline accent.

But turning, by way of technical contrast, to the *Portrait of Charlie* (Figure 53), one recognizes a wholly different technical attitude. This drawing, made rapidly in four or five fifteen-minute poses, called for the most direct, loose, broad-stroke handling. Yet, even here, the same insistence upon emphatic definitions is noted where meticulous modeling of details in the features was essential. The sharpened point was needed to render those definitive characteristics.

The rendering of the jade Buddha (Figure 54) presents a radically different use of the pencil. In order to simulate the characteristic smooth and meticulous modeling of this beautiful jade Chinese sculpture, it was necessary to build up its tonality and to suggest—if possible—the almost translucent quality of this precious stone. Obviously, this could not be done with the abandon of broad-stroke rendering: much of the work was done with relatively sharp points and overworked with soft leads for the darkest accents, which emphasize the lights and reflected lights. The long strokes on the upper chest were applied last to inject a feeling of directness. It is doubtful if printed copies of this drawing can reproduce the subtlety of the original.

In the drawing of that marvelous *Stone Staircase of Wells Cathedral* (Figure 55), there is an interesting textural contrast between the stones of the walls and the smooth, worn effect of the steps that are textured by untold thousands of worshipers who wore them down to their present undulating harmony. Also, the wall and the simulation of sun's rays cutting across the window mullions dramatize the brilliance of the light. Note how the sun has eaten out all detail of the wall that faces its direct rays.

ABSTRACT TEXTURE

Then there is purely abstract texture, which may be described as the technical manner in which our medium is employed to render tonal areas, without reference to their intrinsic nature or their structure. The wall treatment of *A Narrow Street in Assisi* (Figure 56) is a good illustration. In a very few places, to be sure, there are suggestions of stone joints, but the walls are freely brushed in, mostly with long, sweeping strokes.

Abstract texture puts the artist's facility to the test. It reveals the kinds of technical mastery implied by the phrase "following the pencil," which is discussed in the chapter of that title. It succeeds only in spontaneous rendering: it is the kind of technical flair that the student anticipates, but must wait for with patience.

Figure 54. Jade Buddha, Brooklyn Museum, New York

I worked with sharp points to build up the tonality in a way that would simulate the characteristic smooth and meticulous modeling of this beautiful Chinese jade sculpture, as well as suggest its translucent quality. For the darkest accents, which emphasize the lights of this precious stone, I worked over with soft leads. The long strokes on the upper chest inject a feeling of directness.

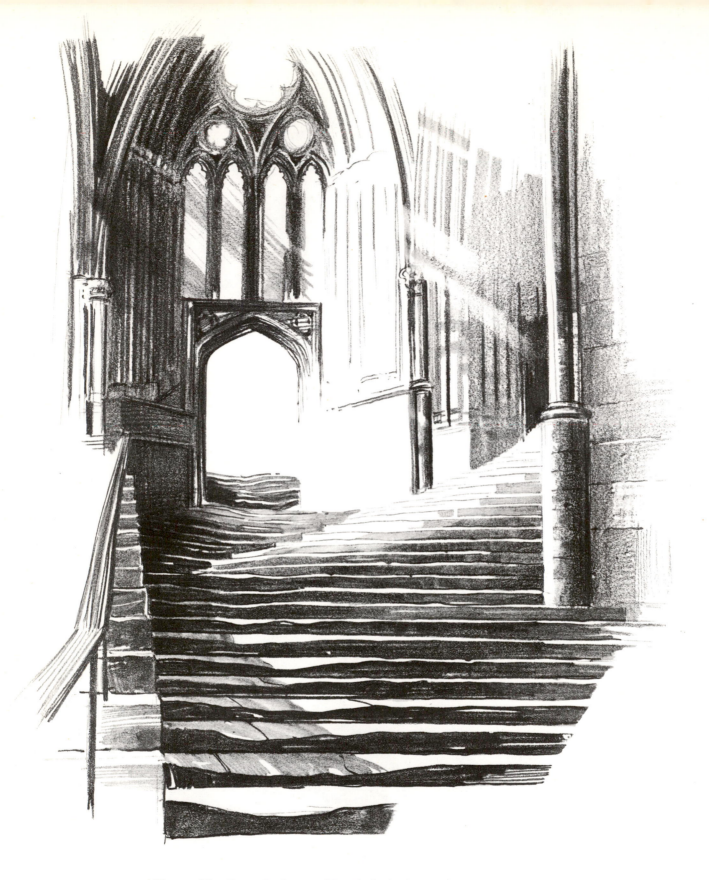

Figure 55. Stone Staircase of Wells Cathedral

Note the textural contrast between the rough, grainy stones of the walls and the steps, worn smooth by the passing of untold thousands of worshippers.

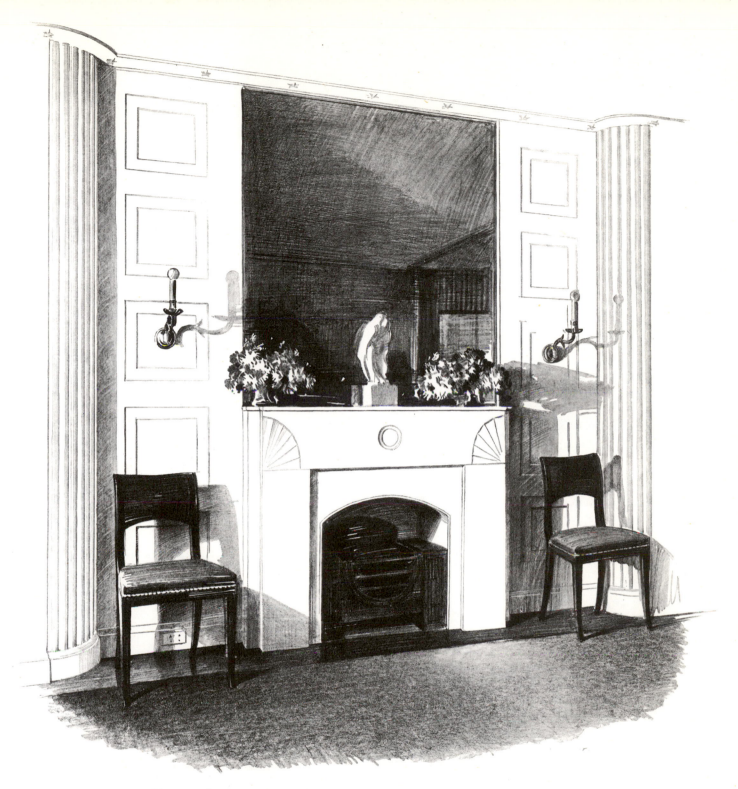

Figure 56. Rendering of an Interior

I made this drawing to demonstrate how a meticulous architectural subject could be effectively rendered with a lead pencil. I used a ruler to lay out the entire drawing, because a mechanical base was obviously necessary to simulate the delicate architectural detail such as the flutings of the columns. The dark reflections in the mirror were a supreme test of the pencil's capacity to render subtle tonal relationships. I avoided a photographic likeness by insisting upon the identity of the pencil throughout. The chairs were done entirely freehand. The clay coated paper permitted white line rendering.

Figure 57. A Narrow Street in Assisi

Canyon-like streets particularly fascinate the artist. I successfully rendered the walls mostly in broad-stroke, working in a variety of directions to suggest the textures in these old piles of stone, brick, and stucco. Long strokes are opposed by short strokes, with occasional introduction of thin line, as, for instance, in the sunlit area near the street level. Notice the streak of sunlight—just a trick to enhance the luminous effect.

Figure 58. Within the Porte San Francesco, Assisi

This detail fascinated me. I show it to demonstrate the many ways the pencil can represent the textural effects of masonry walls. Note the technical variety of strokes on the building that looms up on the left—long, sweeping strokes, with shorter strokes in horizontal and vertical directions. Notice, too, the treatment of the wall facing us. Examine the pattern of light gray tones which represent the masonry. How monotonous this wall would be without the white areas that break into the gray to enliven it and give it a sunlit pattern. The dark tonal treatment of the inclined roadway exemplifies how the structural character of the whole wall is represented in the drawing of a few masonry blocks.

7 SKETCHING IN TOWN AND CITY

Sketching in cities and towns can be very exciting sport, provided the hunting ground is dramatic in one way or another. There must be emotional incentives to bring out whatever magic there may be in a responsive pencil. Moreover, there is a "best" time of day and the right kind of weather for sketching outdoor subjects. The sun should shine and it should be in the right quarter to project those shadows which are vital to a dramatic rendering, especially if you are sketching an architectural subject. Often a subject that is unexciting when seen on a cloudy day becomes thrilling when the sun plays upon it.

EMOTIONAL INCENTIVE

In the chapter, *Looking and Seeing*, I tried to explain the essential interaction between subject and artist. I said that the hand (muscle) was an indispensable contributor to eye and brain in a triumvirate of the seeing process. The response of the hand to the subject is dependent upon emotion. When emotion is rampant, the hand and the tool seem to create almost automatically. I used to say to students, "Let your eye follow your pencil." Well, of course that does not happen in the early learning stages, yet it *will happen*. But it takes unfamiliar or thrilling subjects to set the process in motion. An artist on his first visit to foreign lands where unaccustomed sights greet the eye is caught up emotionally by the romance of fresh environment: it is then that he will do his best work.

I do not mean to imply that one has to go abroad to experience this emotional incentive. If it is harder to find on our own shores, it *is here*. And much, of course, is in the eye of the beholder. Many artists may have passed through the manufacturing town Velati, south of Albany, New York, without being at all excited about what they saw there. But many years ago—a great many years ago—I drove into Velati on my way to Albany, and the place in that quick glance fascinated me. My desire to return there to sketch has persisted for forty years. How many times have I said, "I must go back to Velati"? No doubt the village has changed radically since

Figure 59. An Old Street in Sorrento, Italy

I thought this Sorrento street would make a good subject. The problem here—as in any similar situation—was how far to develop the treatment of the street walls which frame the picture. Usually, the answer is to carry the development as sparingly as necessary to describe the structural situation. But the patterning of these walls was important, and I had to consider how to use the accessories—the doors, the windows, and other structural details—as well as how to handle the arbitrary tonal patterns and their textures.

that faraway day. And I dare say that a chance reader of these lines who knows Velati will wonder what on earth draws me to it. Should I return tomorrow, I might ask the same question.

AN INCIDENT OF THWARTED INCENTIVE

Almost everywhere in Europe the artist finds himself in an emotional environment. Yet given this incentive, incidental circumstance might in some way conspire against him. This was the case in Sorrento on my first European sketching trip. I put up at a pension, high on the tufa cliffs that rise like palisades on the south shore of the Bay of Naples. The place was set in a garden of orange trees with a view of distant Vesuvius. Will S. Taylor, my artist companion, and I conceived the idea of hiring a carriage (those were the wonderful horse and buggy days) and being driven around town in search of subjects. It seemed a good idea, but there was a catch in it. Lack of communication with the driver was one, since neither Will nor I spoke Italian. The driver's idea was to get the tour over with as speedily as possible, but finally we came to a mutual understanding. Our plan, once a subject was selected, was to sit comfortably in our carriage and, lifted above possible interference from the street, proceed to draw at our leisure. We did not count upon flies— yes, flies. Not that they bothered *us*, but they did harry the little horse who (is a horse a who?) shook violently with continuous stamping of hooves. Drawing was impossible. Well, suppose the poor animal were entirely disengaged from the carriage. Suppose, indeed, the puzzled driver could be made to understand the purpose of such an unheard of demand. This finally was accomplished, but not without attracting a deal of attention in the street. The performance brought several curious housewives hurrying to the scene, intent upon learning what this was all about. Three or four of them clambered up the wheels of our portable studio for a look, threatening to make an end of the whole business. They left us finally. *Sorrento Street* (Figure 59) is a graphic reminder of this episode which, you may be sure, was never repeated. The drawing is rather uninspired, but it is shown here to demonstrate how diversions can interfere with spontaneity of execution and result in less than success.

Figure 60. Ruin of Glastonbury Abbey, England

The sun completely revealed the exquisite beauty of this architectural masterpiece. Attention focuses upon the doorway itself. I had to get into the shadows of the doorway with my pencil. Rendering such shaded interiors puts the artist to the test. He must let the light filter in to give some definition to the architectural forms within. This task requires careful disposition of black, with varied lighter tones. To the left of the vertical mass is a glimpse of the ruined nave of the church. The foliage that protectively enfolds the nave is simply rendered, with the white, sunlit masses providing an attractive pattern. Note that the nave wall, though treated in light tone to put it in proper prospective, is rendered with very definite strokes. Beware of getting technically fuzzy in such situations.

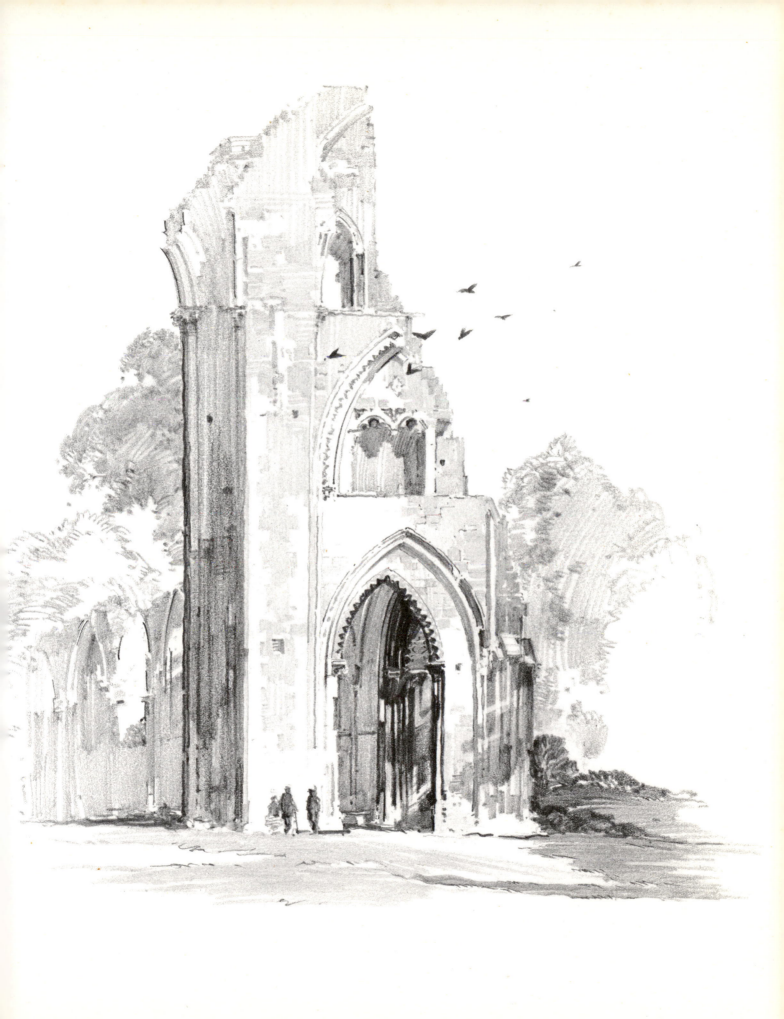

Figure 61. A Steep Street in Yonkers, New York

This street scene, made in Yonkers, New York, for my book How to Use Creative Perspective, *demonstrates the somewhat complicated perspective problem involved in drawing inclined streets. This one, to be sure, is more complicated than usual because it involves three different levels.* Reproduced, courtesy Reinhold Book Corp.

Figure 62. Perspective Diagram of A Steep Street

The accompanying diagram plots the multiple vanishing points present in the perspective of this inclined street. Note that certain groups of objects have common vanishing points, and that only one object—the truck—has a vanishing point all its own.

GETTING ACCUSTOMED TO ONLOOKERS

One has to become accustomed to a reasonable amount of attention from curious pedestrians. You become a public entertainer as soon as you establish yourself in a public place. You have no right to privacy. You get used to this, in time, and should not be disturbed by respectful onlookers. When possible, seek a semi-secluded nook or at least a wall, against which you can sit and enjoy a degree of privacy.

The famous Rialto in Venice (Figure 46) is a very busy thoroughfare. The artist is practically forced to seek a reasonably quiet spot out of the traffic flow. When I went to draw the Rialto, there was but one such place for a favored view of the bridge, and this spot seemed constantly occupied by other artists. I found it vacant after three or four visits to the place.

It frequently happens in situations where you must have a certain vantage point from which you prefer to view your subject that there is no niche or even a wall to protect you. Such was the case when I drew *The Chain Gate, Wells Cathedral* (Figure 9). I had to sit almost in the middle of the street in order to make that drawing from the proper vantage point.

ESTABLISHING A FOCAL POINT

In sketching buildings and streets, one naturally establishes a focal point of interest where detail and tone are concentrated. Other areas and details are subordinated, even though they be essential parts of the environment and necessary to your drawing. These are rendered suggestively, with lighter tone, or perhaps in line only. Getting out of the picture gracefully is a sketching art which one learns through experience. By this I mean the treatment of the sketch's periphery in such a way as to make a suggestive connection with adjacent buildings or other surroundings. This may be done by lightening values at the edges or resorting to line indication.

Sometimes the focal point—where one concentrates tonal contrasts—is a relatively small detail, as is the portal at *Glastonbury Abbey* (Figure 60) in England. In such a case, the other architectural elements are not slighted in any way, but are rendered with light tones and delicate delineation. The drawing of the *Wells Cathedral Tower* (Figure 2) might be mentioned similarly, all parts of the drawing being designed to lead the eye up to this pinnacle of architectural delight.

KNOWLEDGE OF ARCHITECTURE

It goes without saying that reasonable familiarity with architecture is essential when sketching in city streets, especially so when historic buildings are involved. And in such subjects, the ability to "draw a straight line" is an obvious advantage. Many times I have been asked if I resort to mechanical means in drawing intricate architectural subjects and if I use a ruler for verticals or other structural lines which demand meticulous accuracy in rendering. While I do not need or use such aids,

Figure 63. Studies in Proportion

These illustrations demonstrate how to measure proportion, with the 2" square viewer as the unit of measure. In 63A (top), the square first divides the cathedral into upper and lower halves (top left). To adjust subsidiary parts of the subject to the all over form, the square is simply moved farther away from the eye (top right). In 63B (bottom), though the three squares are quite obvious at first glance (bottom left), a large enclosing square is still desirable as a first measurement. From my book, How to Use Creative Perspective. *Courtesy, Reinhold Book Corp.*

I do not consider that the use of a ruler lightly to establish such lines inhibits spontaneous rendering.

PERSPECTIVE AND PROPORTION

A practical knowledge of perspective is a necessity, as is an educated sense of proportion. Perspective is too involved a subject to be discussed in this text, which is focused upon rendering rather than on delineation. However, I shall allude to the problem of drawing inclined streets, which, I have found, gives trouble to students who have little difficulty drawing level streets. And I borrow, for this purpose, a page from my book, *How to Use Creative Perspective* (Reinhold Publishing Corporation). This page reproduces a sketch of a very steep street in Yonkers, New York (Figure 61). Essentially, the problem is to determine not one vanishing point, but a series of vanishing points, as I have indicated in the diagram. On an inclined street, different objects may tilt this way or that way, and do not necessarily have a common vanishing point. Thus, each object must be considered separately and drawn to an appropriate vanishing point which may be high or low, as the street dips or rises. In the diagram, you will find that various groups of objects have common vanishing points, and only one object—the truck descending the hill—has a vanishing point all its own. This drawing, with the line analysis (Figure 62), should clarify the problem sufficiently.

I am inclined also to dwell briefly upon proportion because in my teaching, I have been surprised to find that students proficient in perspective lacked an adequate sense of proportion, or at any rate were not applying it in their renderings. Proportion is identical with measurement. We must measure by some means everything we draw. Actual measurements being out of the question, the sketcher sometimes is seen holding his pencil at arm's length and squinting his eyes as he steps off dimensions on it with his thumb, thus attempting to compare dimensions. Such measurements are inaccurate; you will never see a professional resort to this method.

A more reliable method relates the subject to geometrical figures, the obvious figure, of course, being the square. If one has a correct concept of a square, there should be little difficulty with proportions. I have advised students to outline a 2″ square in India ink on a small piece of transparent plastic. By examining the subject through this measure, and by moving it nearer or further away, the square will conveniently appear larger or smaller to adjust to any part of the subject or to its entirety. The accompanying diagrams (Figures 63A and 63B) will illustrate how this measure is applied to architectural forms.

Figure 64. Campanile of the Cathedral at Fiesole

In this meticulous rendering, I was more concerned with accuracy of detail than with making a dramatic sketch. In the shaded side of the tower, emphasis was focused upon the upper half, where I made the tones quite dark. Below, very light tones with open line shading give a transition to the white façade of the building.

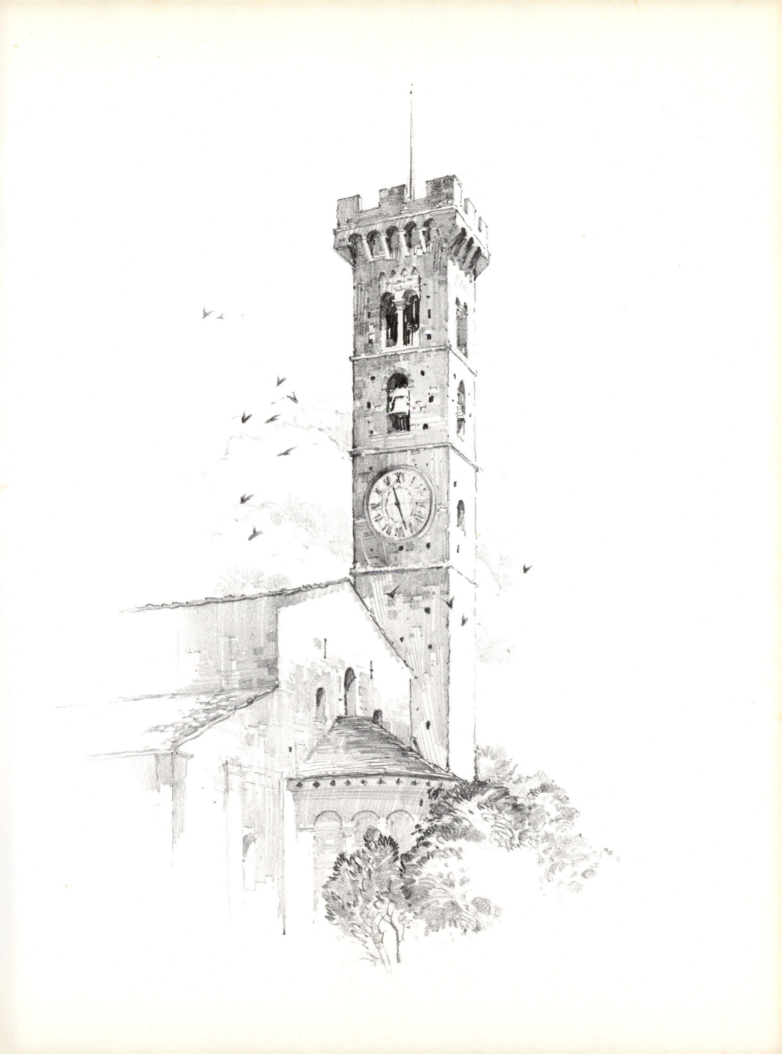

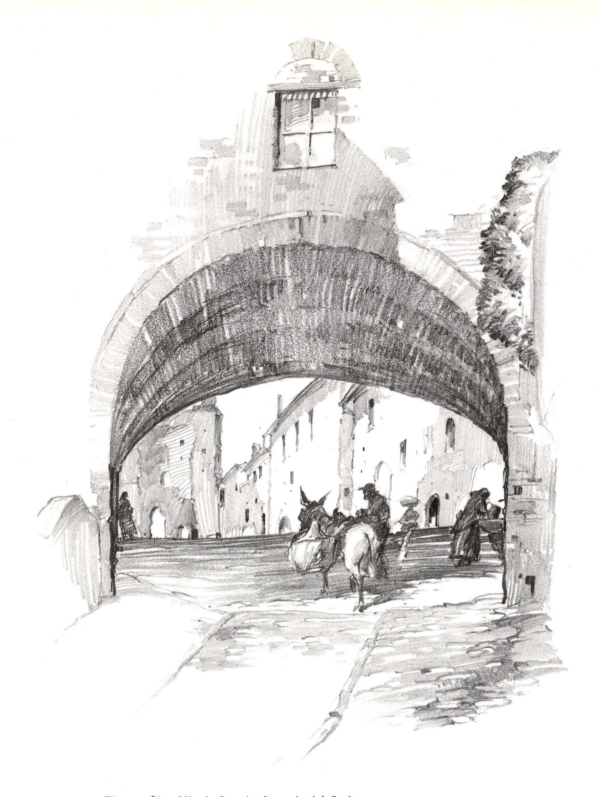

Figure 65. Vicola San Andrea, Assisi, Italy

In this scene, attention is so exclusively centered upon the view through the arch, that surrounding details are scarcely noticed. A minimum of structural support to explain the architectural reality of the arch, plus enough foreground to get us into the picture, is all that is needed. Rendering such a large, dark area as the arch is always a problem in pencil drawing. I thought it advisable to direct my strokes to conform with perspective. Notice that the dark is intensified at the far edge to enhance by contrast the impression of the sunlit façade on the plaza beyond.

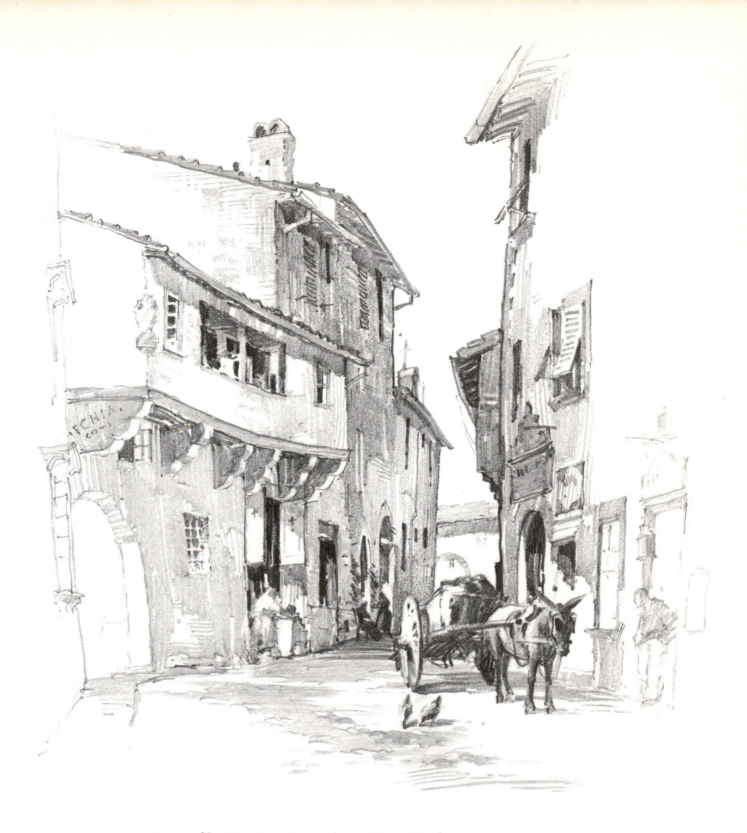

Figure 66. The Main Street of Borg 'Unto, Fiesole

What I said about the technical treatment of ancient walls of the Assisi street (Figure 65) applies equally here. Also note the treatment of the right side of the street—the way I faded out the detail near the street level to terminate the sketch there, using such structural details as doors, windows, and sign. These details are compositional niceties one learns to utilize in creating a sense of the street's identity as a part of a larger scene.

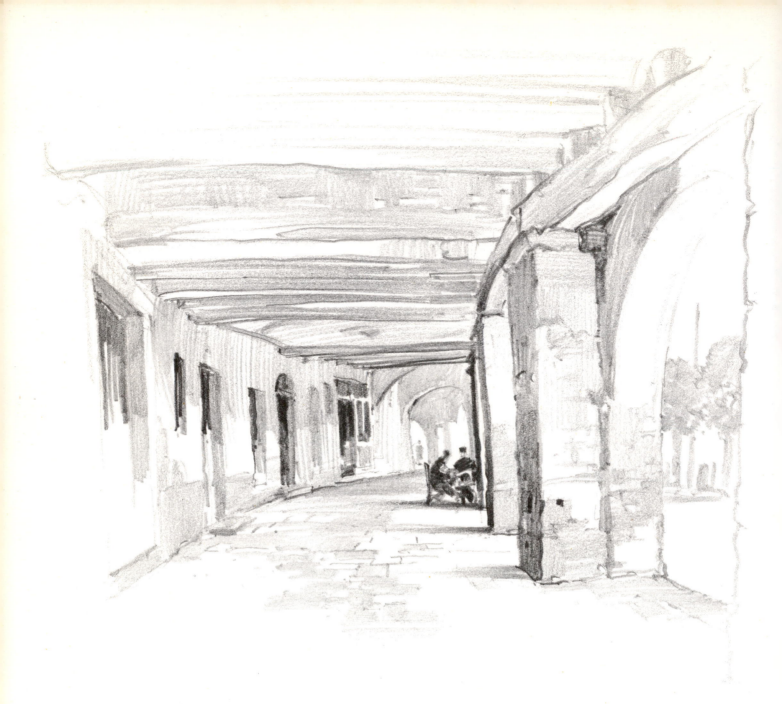

Figure 67. Colonnade at Marcote, Lake Lugano, Italy

This inconsequential architectural subject attracted me sufficiently to warrant making a half-hour sketch while I awaited transportation by boat to Lugano. The dark figures seated at a table give needed punch to an otherwise monotonous tonal scene.

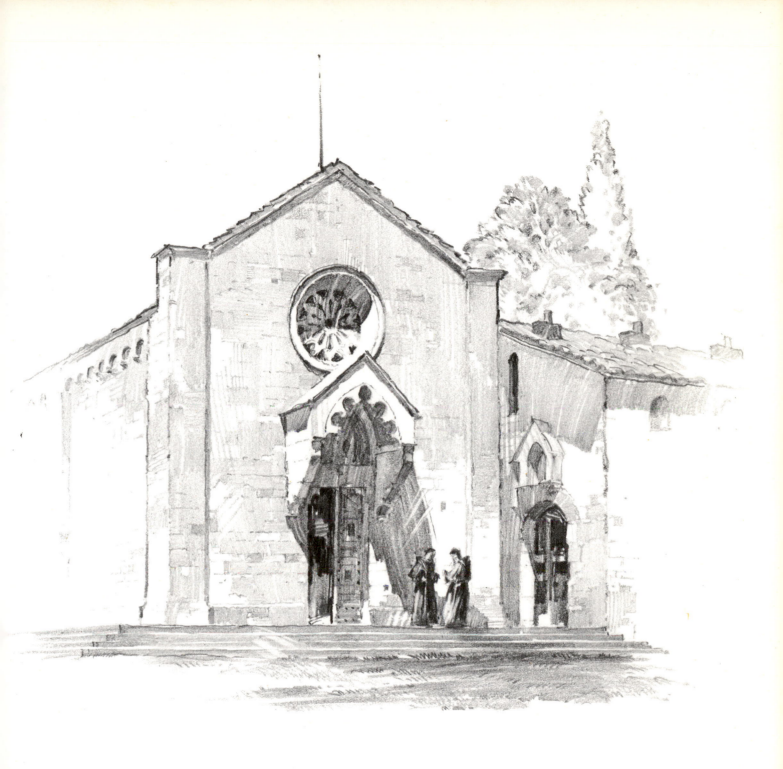

Figure 68. Franciscan Monastery at Fiesole

The doorways of this detail of the Monastery attracted my special interest. The sun was at a favorable angle to give a dramatic pattern of light and shadow. Note, however, that an arbitrary area of white breaks into what was undoubtedly full shadow, and serves to enliven the rendering at that point. Within this darkened entrance, one notes a studied relationship of dark values to define details within the shadows.

Figure 69. Carriage at Sorrento, Italy

This tiny carriage was sketched from the balcony of our room in the Cocumela pension. In it, my artist friend Will S. Taylor and I took many sketching tours during June, 1925.

Figure 70. Freight Carts in Florence, Italy

This scene was drawn in 1925, long before the intrusion of the motor age which has done such violence to the picturesque streets all over the world.

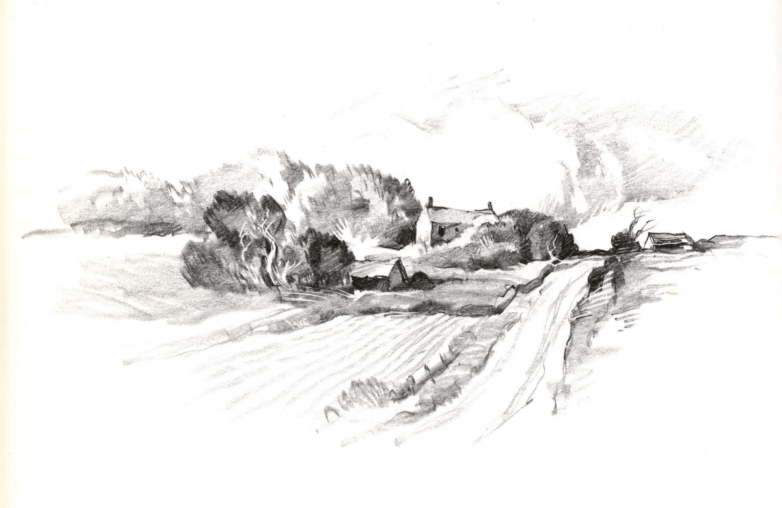

Figure 71. The Old Post Road

In this landscape, the old house and the foliage surrounding it seemed a particularly happy motif. I had only to make the most of what the subject offered. I did change the direction of the road and plowed a field alongside it. This is a very small sketch. I could not otherwise have rendered it so completely tonal as I have done. The moment an artist tries to draw such a subject in large scale, he runs into trouble. The cloud mass was certainly designed to give what I think is an invitation to the imagination to continue over the hill down to a pleasant valley. The drawing is on Video paper.

In landscape sketching—where the brush is supreme—we are aware of the limitations of the pencil. The brush, with its color and tonal characteristics, poses no problem in representing broad areas of landscape, which can be brushed in with as much faithfulness to natural appearance, and on as large a canvas, as may be desired.

USE OF SYMBOLISM

The pencil artist, unable to render the breadth of fields and hills with an agreeable degree of tonal similitude, must rely upon the sort of imagination described in the simple diagrams in Chapter 10. With line and with areas enclosed by line which are augmented by restricted tonal rendering, the artist tries to give an illusion of reality that is acceptable to the observer. We have noted that the audience has been conditioned from childhood to accept symbolism of line in picturization. Thus, a cow sketched in a field of white paper creates a pasture, otherwise completed with as many imagined natural phenomena as the experience of the observer is qualified to supply. With a city child who has never traveled beyond a concrete environment, this contribution of imagination based on experience would, of course, be negligible. But the audience we are concerned with does not require the presence of a cow.

SIZE IN LANDSCAPE SKETCHING

In another chapter, we considered the question of size in pencil sketching. There the discussion dealt with the rendering of buildings viewed at varying distances. Size in landscape sketches has to do with the limitation of the pencil in rendering sizeable tonal areas in an acceptable manner. The pencil, as previously stated, is not adapted to rendering large tonal areas. In this respect, the limitations of a pencil drawing resemble the limitations of an etching, which is at its best in small renderings. Beyond a certain size, the pencil cannot cope effectively with tonal relationships.

My own solution in landscape drawing is to keep the size within acceptable limits. Refer to the sketch *The Old Post Road* (Figure 71), which has a maximum width of 8″. In a sketch of this size, the tonal qualities of pencil masses can be exploited adequately, as I believe they are in this example. If I had drawn the subject twice this size, I could not have produced a comparable rendering. This consideration is especially valid when really black tones are vital, as they are here. Anyone

who uses pencil recognizes the impossibility of putting good tonal quality into large masses. And I am inclined to ask what would be gained by a larger rendering of this particular subject.

I realize that some artists just cannot work at small scale. A large scale worker who might draw the same subject twice the size as I would sketch it would not attempt to render it in the same manner. I would not say his result would be less appealing than mine, but his achievement would depend less upon tonal relationship than upon other virtues. Size is not actually a consideration in a pencil sketch, which usually is not intended to be framed and displayed on a wall—at least where it would compete with a large picture. Be that as it may, I have two pictures on my study wall which are my favorites: one is an engraving of a rural landscape, 2" x 3½", by Thomas Nason; the other, a wood engraving, *Christ Raising Lazarus*, by Bernard Brussel-Smith, is 6" x 7". No, the size has no relation to bigness of conception. Adequacy of expression is what counts!

Practically all my drawings in this book are shown at exact size; three or four are slightly reduced. So, I would say, choose another medium if you must work at large scale.

SKIES AND CLOUDS

My *Rocky Promontory* (Figure 72) falls in the same category as *The Old Post Road*. They are the same size. In both these subjects, the treatment of the sky is a dominant factor, particularly in *Rocky Promontory,* where I gave considerable thought to designing the cloud masses. I seldom go this far in sky rendering; I find that in most sketches the barest indication of cloud contours, with a bit of shading, suffices. Cloud forms are important also in *Delray Beach, Florida* (Figure 73), where they are needed to give compositional support to the tonal ocean and the wind-blown palm tree. The study of *Rocks in Larchmont Harbor* (Figure 34) also seems to profit from a darkening sky.

It is obvious that familiarity with cloud forms is an asset to the landscape artist, however slight their need may be in many, if not most, of his pencil drawings. As I look through my own drawings, in writing this, I discover that I largely neglected rendering sky forms, and that in many sketches where some cloud indication was needed, I settled for a purely linear rendering.

AN INTERESTING PROBLEM IN LANDSCAPE SKETCHING

Jersey Landscape (Figure 74) illustrates an interesting problem. I was intrigued by a group of trees in the distance, and decided to render them with as much detail as distance seemed to permit. To accomplish this, I seized upon the most prominent aspects of silhouette, which I combined with limited detail of the structure and the lighting. After rendering the trees, I felt the necessity of expressing their distance

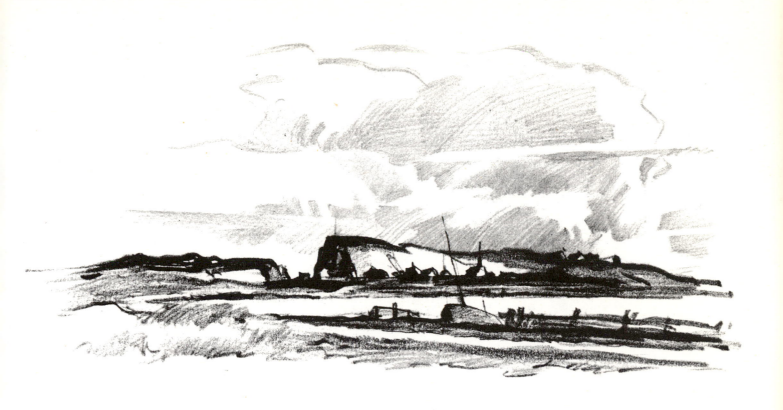

Figure 72. Rocky Promontory

As in The Old Post Road *(Figure 71), the sky is the dominant factor in this drawing. I gave considerable thought to designing the cloud masses here.*

at the border of the marshy field. So I selected from the nearby scrubby growth what I considered necessary to accomplish this effect. I was careful to keep the foreground light enough in tone to subordinate it to the distant trees, thus preventing its attracting attention. While giving thought to its structure, I wanted people to look *over* the foreground instead of *at* it. The intervening reach of field needed a link to connect it with the foreground and background. I tried to attain this liaison with light line indications that would lead the eye from foreground to background.

As I contemplate this drawing now, I think it helpful to emphasize the importance of clean definition of tones—even the lightest tones—and avoidance of fuzziness. This sharpening of detail does not interfere with whatever tonal delicacy one desires: it implies positiveness as opposed to indirection. White structural indications, I think, should be given emphasis, and not permitted to lose their basic function as supporting features.

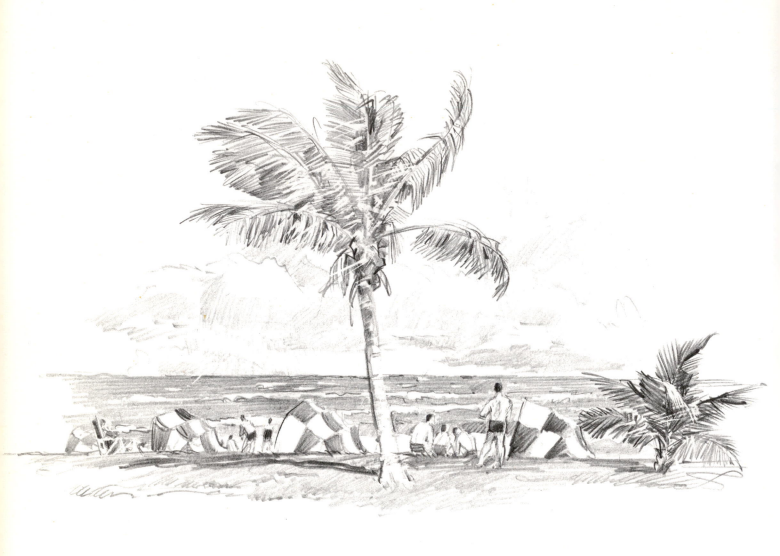

Figure 73. Windy Day, Delray Beach, Florida

This sketch is interesting for several reasons. Notice first how the ocean is rendered in a brush-like manner with a broad-stroke technique. This technique could be done without overreaching the scope of the pencil because the white caps and surf supplied a pleasing break in an otherwise flat, rather heavy tone. Note that these white caps repeat the pattern of the cabanas on the beach. The action of the palm clearly indicates the force of the wind as its fronds bend before it. The low growing palmetto, with its more resistant fronds, takes a swirling motion. It is rendered with a sharp point of very soft pencil. I was able to use the razor blade to scrape out many palm fronds across others of opposing directions, because the drawing is on clay coated paper. The cumulus clouds were added with a broad stroke of a medium pencil.

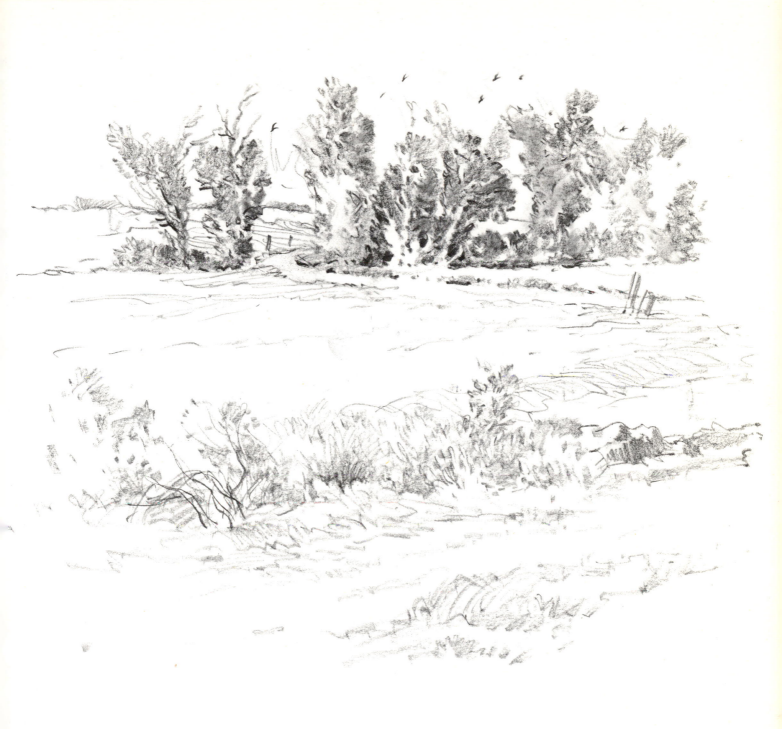

Figure 74. Jersey Landscape

In this sketch, interest is focused upon the distant row of trees, rather than on foreground detail. This is the only drawing in the book which is enclosed by a border line. I am invariably concerned with getting out of the picture gracefully, for I feel that the sketch should obviously be a selected part of the larger environment. Here the border seemed necessary to connect the foreground and distance, otherwise separated by a relatively neglected middle distance.

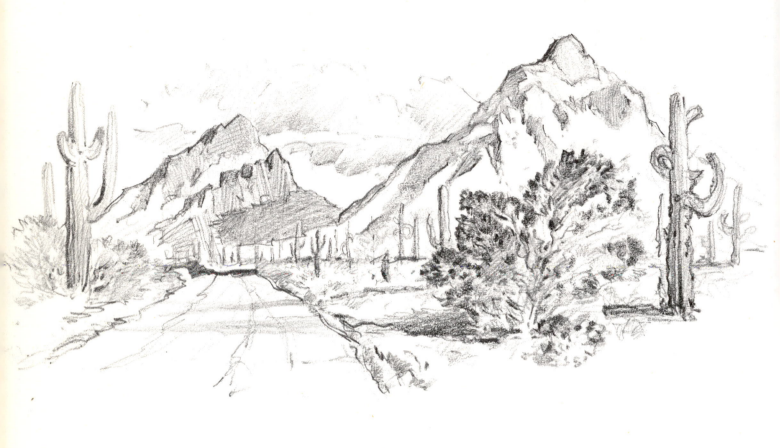

Figure 75. Road to Gates Pass in Tucson, Arizona

This desert road approaches the pass to Tucson from the south. Shortly beyond, it begins to ascend the very dramatic road—a gravel road at the time this sketch was made—which connects the town and the country on its southern border. This rather hurried sketch was done with soft lead on Alexis pencil paper. The pattern of light and dark on the mountains always intrigues an artist and gives him very definite shapes to work with. This composition seemed to require a tonal cloud treatment to connect the two peaks. The dark rendering of the palo verde bush in the foreground gives the scene perspective.

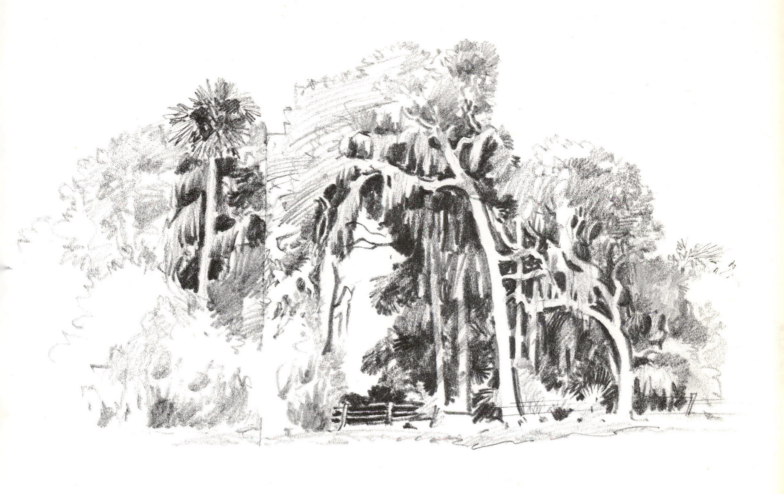

Figure 76. Live Oak Arch near St. Augustine, Florida

Florida foliage offers many delights and surprises. Sometimes forests or their remnants present dramatic compositions, as does this detail not far from St. Augustine. Live oaks draped wih Spanish moss arrest the passing artist, and compel him to record their unusual forms with pencil or brush. To render the effect seen here required generous use of soft leads to simulate the dark, shadowy interior. I tried to avoid solid tone by introducing slashes of white—sunlight striking through—to dramatize the shadowy depth. The moss draped over the branches is a detail that lends melancholy beauty to the scene.

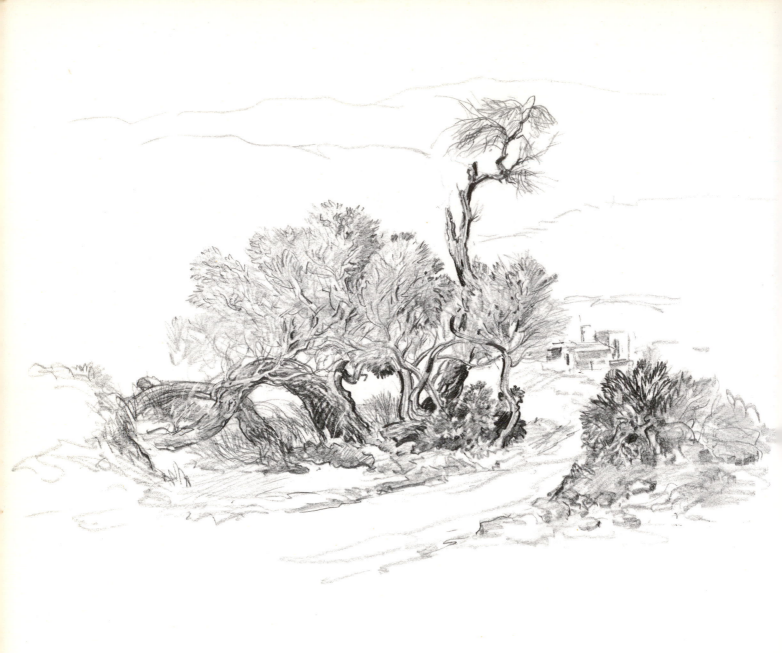

Figure 77. Dead Live Oaks at Banner Queen Ranch near Julian, California

This is one of several live oaks which were dying in a valley parched through want of water. A few branches spring out of the dying trunk in a last effort to hang onto life.

Many sonnets have been penned about the glory of trees. Trees have indeed been the object of worship in primitive societies. They have shared the concept of divinity with mountains, the sun, and many other natural phenomena. If today trees are not regarded as sacred, the naturalist's and the artist's love for them is but a short step removed from worship. At any rate, trees are beings—they are alive—which are a wonder and a delight to those who, for one reason or another, have more than ordinary association with them.

Many years ago I had a friend, older than I, who was professor of comparative religions at a midwestern university. A giant of a man, he felled trees in the forest and hewed them into logs for a cabin which he built upon the shore of a Berkshire lake. He had a way of resting his hand upon the trunk of a great tree as upon the shoulders of a companion, and gazing upward silently into its branches. It would seem most unlikely that the artist who habitually draws or paints trees could fail to share that kind of empathy with them. Some trees, like the giant sequoia, are approached with the awe and respect due the mighty. But one can be on intimate terms with the apple or the dogwood as well.

Trees, like human beings, often do astonishing things. Their eccentricities are intriguing. They twist and turn in the most unexpected ways—almost always, it would seem, with an instinctive sense of good design. And when they die, they usually do so with dignity and artistry.

I would appear to be addicted to dead trees, there are so many of them reproduced in this book. Well, I must plead guilty, although I've drawn countless trees in the glow of health, fully foliated. For it is the skeletal structure of trees that fascinates me, particularly those that are aged enough to display the character which they have acquired during their lifetime.

A SKETCHING TRIP

At Banner Queen Ranch in the California mountains north of San Diego, there was, in 1961, a marvelous group of dying oaks which may have disappeared by this time. I was on a sketching trip with Roy Mason, the noted watercolor painter. We spent a number of days at the ranch, he with his brushes, I with my pencils. A picture he painted there won the American Watercolor Society Gold Medal that year.

These trees had been nourished by a mountain stream which, for some reason, had ceased to flow with sufficient volume to support them as in past years. Two of my drawings of the trees (Figures 77 and 78) are reproduced in this book.

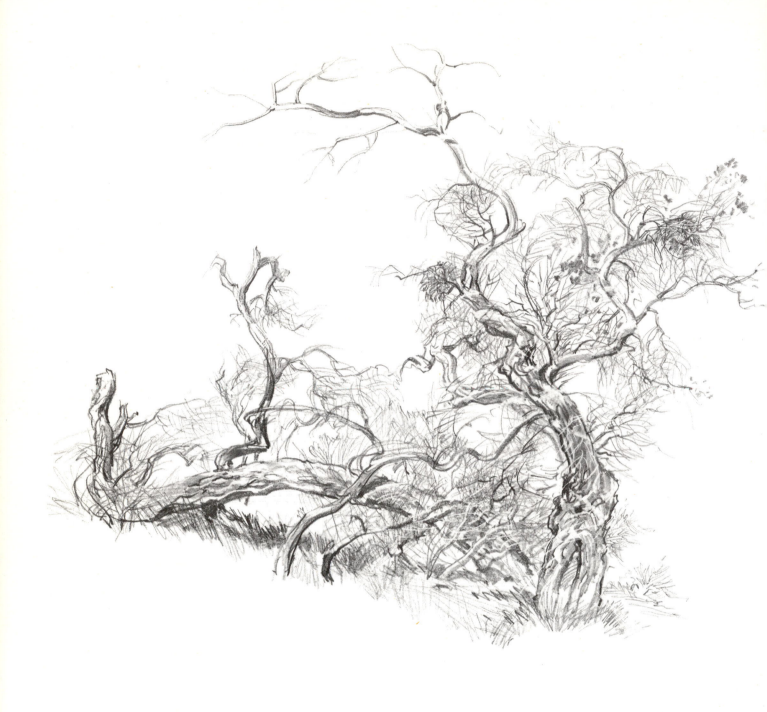

Figure 78. Another Dead Live Oak Tree at Banner Queen Ranch

It should be evident that I had an exceptionally delightful time with this drawing, which invited technical virtuosity. It is as exact a transcription of the subject as I could make, because everything about it was appealing, from the beautiful upward writhing of the main trunk to the fascinating texture at its base. The fallen trunk behind is a wonderful supporting form for the standing tree. The texture of its bark is carefully rendered, and the small sinuous trees that fall over it cast black shadows. The tangle of fine twigs adds a pleasant contrast to the heavier forms. The two small dark masses in the standing tree are clusters of mistletoe.

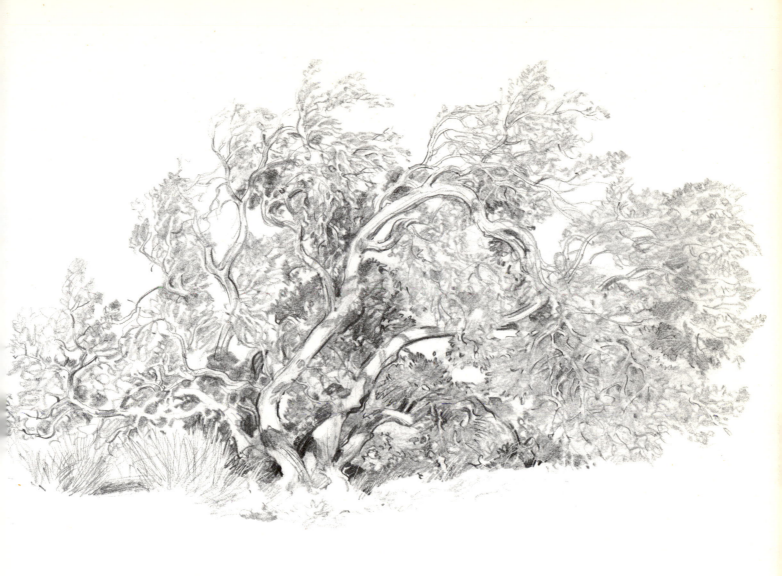

Figure 79. A Very Large Sycamore at Banner Queen Ranch

Evidence of strong winds having bent the tree give it a writhing character that is rhythmically delightful. The trunks and branches, beautifully exposed, form a visible framework supporting the foliage masses. These are silhouetted, light against dark, with shaded masses behind them. Some of the branches are seen dark against light. The drawing of this tree required two hours of intense application to portray its exact structure. It is rendered on clay coated paper, 7″ x 11¾″, with medium soft pencils which give very black tones on this paper. Lighter grades of pencils were used for much of the foliage mass. This was a rather exhausting performance. Artists who do not draw from nature cannot realize that it can be real labor, as well as great pleasure. I remember having a lame back and neck when the drawing was completed, just before dusk on January 25, 1961.

By contrast, an enormous sycamore (Figure 79) grew nearby. It was copiously foliated, but it revealed its structure dramatically in a web of writhing branches, the two main trunks of which outlined an odd pear-shape, which was the basic form to build on.

PALM TREES

When first I began drawing palm trees, they seemed somewhat baffling. It is easy to make them resemble glorified dusters. The main thing is to establish definite patterns of light and shade areas among the waving fronds. One technical difficulty is caused by the way the fronds in places break and droop against fronds on the other side of the stem. When you work on clay coated stock, you can handily scrape these out with the razor blade. Otherwise you must work around them with dark tone, a somewhat laborious procedure. I found myself using a fairly sharp point in simulating the sharply pointed fronds, often emphasizing their tips. A comparison of the sketch of *Wind-blown Palms* (Figure 80) which were among the first palms I had drawn, with later palms such as *Portrait of an Egret* (Figure 81) illustrates this point. A different technical situation is encountered in the drawing of the dead maple (Figure 52). Here we are absorbed by the fascinating textural impact of growth scars on the weathered trunk, and the fragmented beauty of shattered branches.

SILHOUETTE

From a distance, a tree in full leaf appears as a silhouette, lacking light, shadow, and other detail (Figure 82). But its basic character is revealed by the simple form. As we draw nearer, when the foliage is dense, the clusters of leaves are defined by sunlit areas and their shaded parts (Figure 83). When the foliage is sparse—like that of the locust trees (Figure 89)—there is no such light and shade effect.

At close range, branches become prominent, sometimes light against dark foliage and sometimes dark against light, or openings in foliage masses. It is then that knowledge of the ways trees grow is invaluable. But the silhouette aspect should always be kept in mind, and the tree character, thus simplified, retained—no matter how much detail is involved in the completion of your drawing.

GEOMETRIC ANALYSIS OF TREE FORMS

We learn most about tree structure when, after the leaves have fallen, we have an unobstructed view of trunk and branches. Such knowledge is as indispensable to the landscape artist as familiarity with the structure of the human skeleton is to the painter or illustrator.

I have selected a fascinating subject (Figure 84) to demonstrate a method of

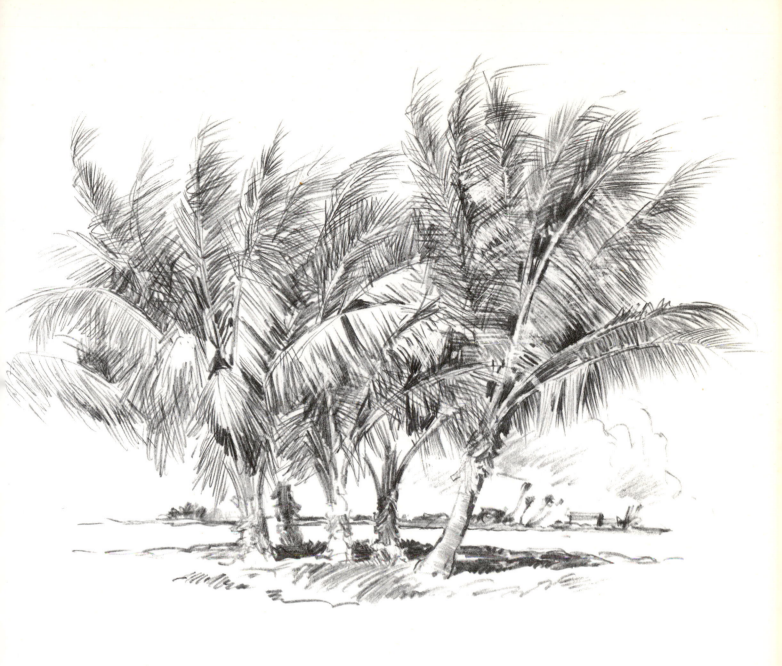

Figure 80. Wind-Blown Palms, Lake Worth, Florida

This is a rapidly sketched group of palms which were flailing about in a stiff breeze. The drawing was made with a single soft lead on Alexis paper. The pencil had a rather sharp point, instead of a bevel edged point. There could be no scraping out of white fronds, since I was not working on clay coated paper.

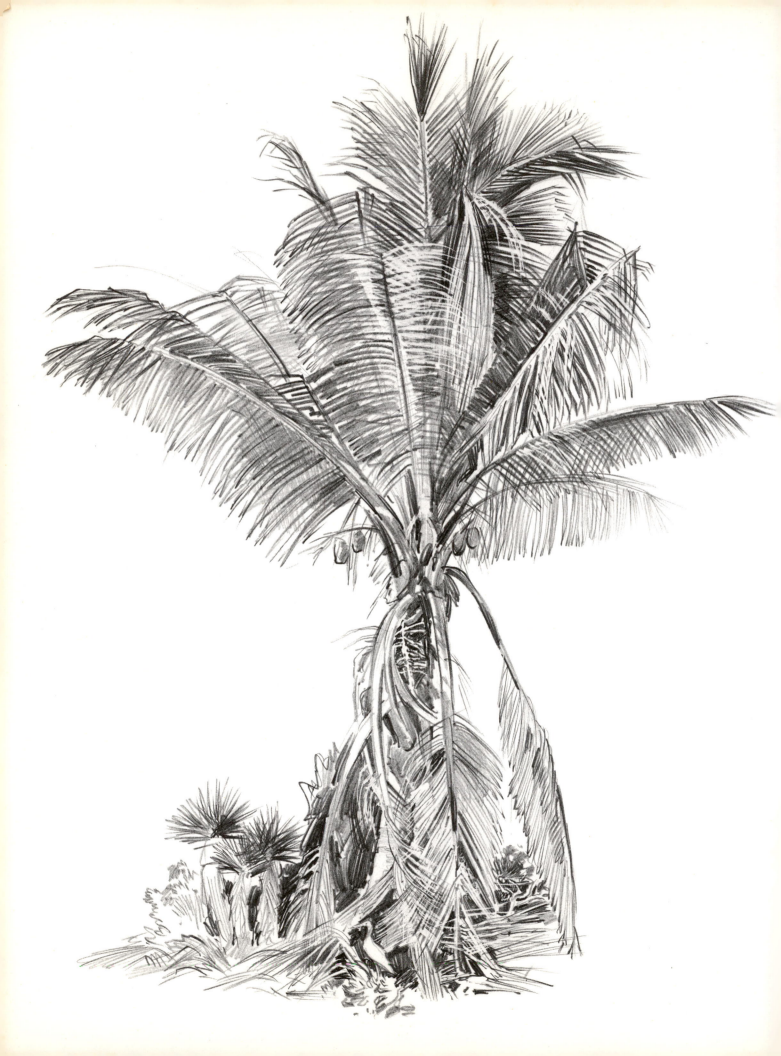

geometric analysis in portraying the characteristic forms of particular trees. This subject is a bare banyan tree, which I discovered near Boynton Beach, Florida. I was at first startled by the elk-like form of the main trunk, which seemed to stand upon legs (they are really aerial roots) and hold its antlers high in the air. The aerial root structure accounts for many eccentricities of the banyan. As the tree grows, it lets down more and more of these roots from its branches, until finally the mass of the trunk members becomes enormous.

The banyan, unlike deciduous trees, retains its foliage perpetually, so evidently this was not a living tree. Yet its skeleton had not yet lost even its incidental branches. I have made three diagrams (Figure 85) which reveal the order of my analysis. In A, we discover how a right angle gives an encompassing form, and we take note of the enclosing arc which touches the tops of the branches. In B, the analysis is further developed with the identification of the prominent v-shape, which could, indeed, have been a starting point if not for the fact that I always like to begin with the most inclusive form. This v-shape is constructed upon a vertical, center-dotted line. In C, we isolate the smaller v-shape, which also has a vertical center line. Recognition of a rectangular mass—nearly square—is yet another aid in our analysis. There are other minor geometric relationships that appeared as I continued my analysis.

Now I have taken pains to select for this demonstration a tree which offers unusually obvious geometric references. Yet every tree can be analyzed to some extent through geometric reference. Indeed, we can go so far as to say that it has to be, if we are faithful in portraying a tree's character. *Every* subject we draw has first to be measured somehow in order to represent its individuality. Geometric form is the only reliable reference we have.

Before leaving this drawing subject, I call attention to the palmetto, which serves as a pleasant textural accessory for the banyan. The palmetto was not actually growing there but palmettos have an environmental affinity with the banyan.

This drawing on Video paper was rendered with two pencils, one very soft lead, the other medium. Note how shadows of branches are cast upon other branches. This effect should not be overlooked; it enhances the illusion of reality.

I have emphasized becoming familiar with characteristic tree structures. In winter, when trees are bare, one should study structure, unhampered by foliage. This study usually can be done while you sit in a heated car. In addition, another excellent method of study is drawing twigs in the studio. Collect a variety of twigs of different growth types. Meticulous drawing of these twigs will be most profitable, since, in effect, they are miniature branches of grown trees.

Figure 81. Portrait of an Egret

Just as I was finishing sketching this palm tree, a handsome white fowl alighted in the very spot I was drawing. The egret made a white silhouette against the dark, shadowed area at the base of the tree. The clay coated paper on which I was working enabled me to scrape out the bird's white form with a razor blade.

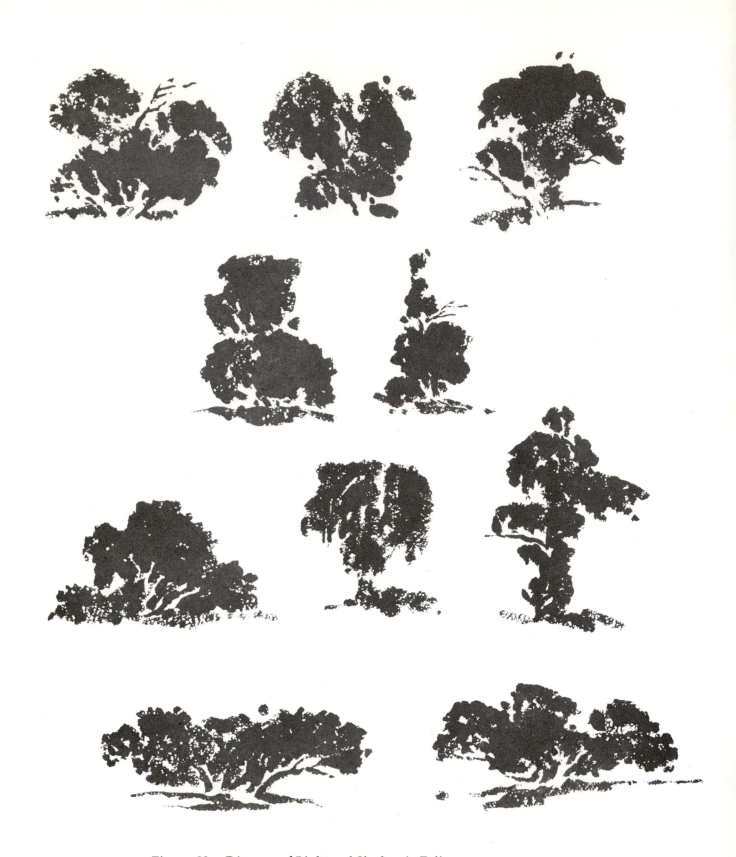

Figure 83. Diagram of Light and Shadow in Foliage

As we approach the tree with dense foliage, the clusters of leaves become defined by sunlit areas and their shaded parts.

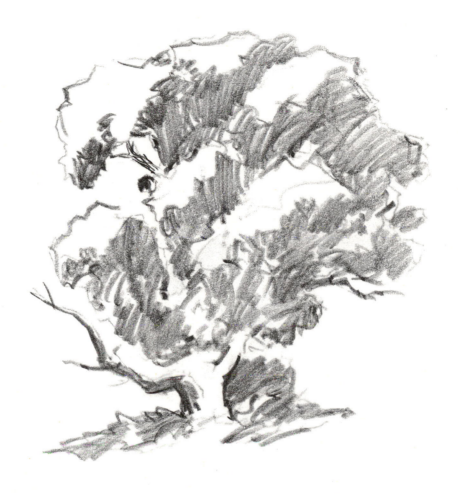

Figure 82. Silhouettes of Trees

Drawn from a distance, trees in full bloom appear as silhouettes, lacking light, shadow, and other detail. Basic character is revealed by the simple form.

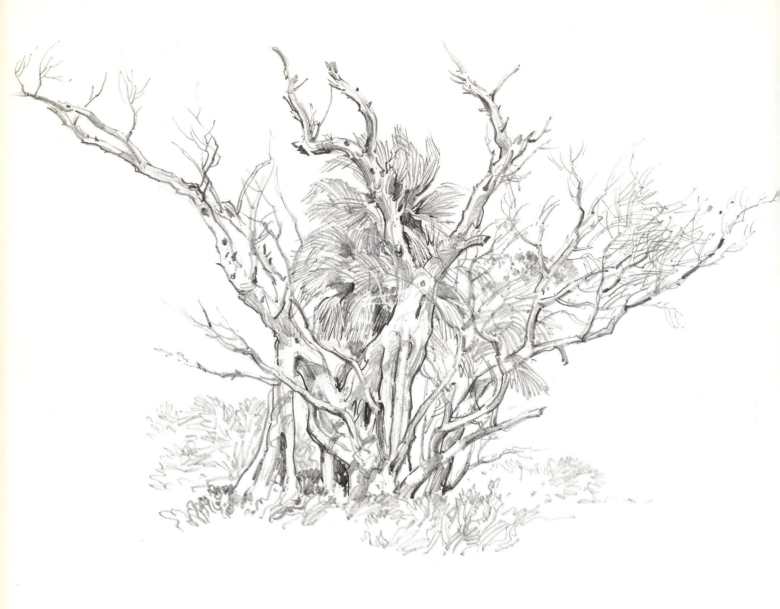

▲ **Figure 84. Dying Banyan Tree, Boynton Beach, Florida**

This dying banyan tree caught my attention, and I became fascinated with it as I drew. It is an ideal subject to illustrate my analysis of tree structure, and I made three diagrams (Figure 85) to show the order of this analysis. Although this tree offers unusually obvious geometric references, every tree can be analyzed to some extent through this approach. Indeed, we can even say that it has to be, if we are faithful in portraying its character.

Figure 85. Geometric Analysis of Structure of Dying Banyan Tree ▶

In A (top), we discover how a right angle gives an encompassing form to the branch structure. In B (center), the analysis is further developed with identification of the prominent v-shape, which might well have been a starting point, if not for the fact that I like to begin with the most inclusive form. This v-shape is constructed upon a vertical center-dotted line. In C (bottom), we isolate the smaller v-shape, which is also built on a vertical center line. Recognition of the rectangular mass—nearly square—is yet another aid in our analysis.

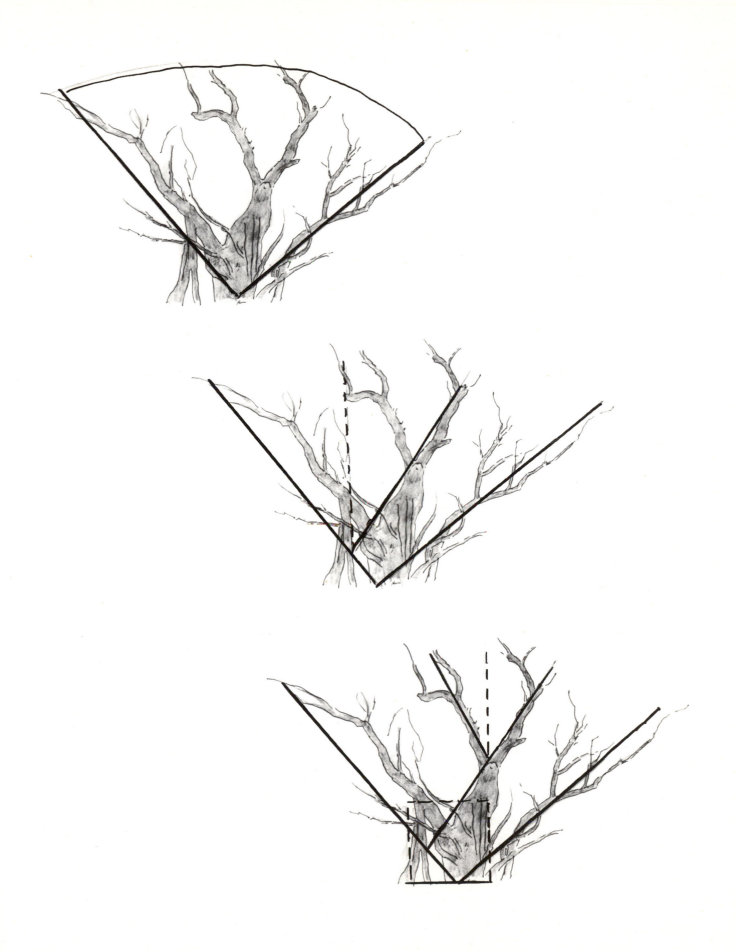

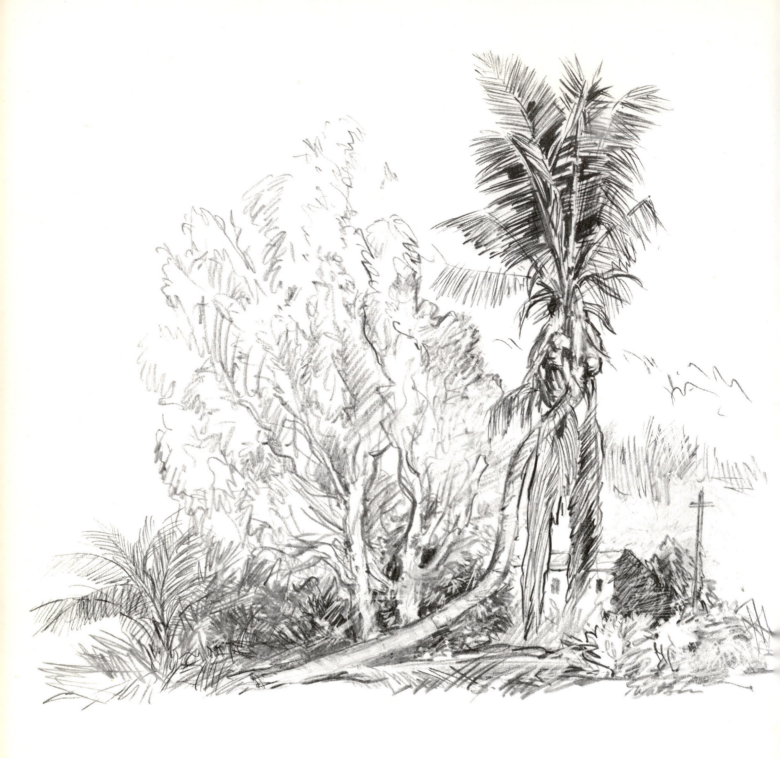

Figure 86. Neglected Palm Tree at Delray Beach, Florida

This tree seems to have had a poor start in life, bent in its youth almost level with the ground. But it finally raised its head in a remarkable performance of rectitude. In spite of its handicap, it bears fruit and tries to look healthy, although its upper fronds appear somewhat broken. Those which hang almost to the ground have great beauty of form and detail—they were a delight to draw. The top fronds were rendered with a very soft, sharp lead, capable of producing solid black masses and sharply pointed fronds. The little punk trees give a kind of friendly support to the palm, but are not interesting in themselves. The foreground is a rather formless scumble.

10 MEMORY AND IMAGINATION

Drawing from memory is a wonderful discipline. It helps one develop the art of simplicity—and simplicity *is* an art. I have often recommended the following method of study.

WORKING PURELY FROM MEMORY

If, when driving through the countryside, you come upon an eye-stopping landscape—something you would love to sketch—stop your car and sit in it or on the stone wall bordering a field, and try to organize the subject. Without benefit of even a slight pencil notation, create a strong mental picture of the scene to take back to your studio.

Do not try to memorize details, as though you hoped to reproduce the scene in photographic completeness. You cannot do this, and you shouldn't even if you could. First ask yourself what attracts you to the subject. Fix the big elements in mind: their shapes, their essential character, and their relative importance to each other. Don't try to remember incidentals; focus upon the broad compositional ensemble. Plan your picture: the size of the maple tree and its relation to the barn or house, the proportion of the house, the shape of the roof and chimneys, etc. Try to picture it all mentally.

Take a good long time recording this picture on your memory film. Make it a broadly painted picture, with the elements simply massed in. If you try to remember detail you are lost, unless you have an extraordinarily photographic mind.

Now you will find that you can remember that scene when you return home —even the next day. Quickly sketch its broad aspect just as you remember it. Don't allow any time for elaboration. The shorter the time, the better. Repeat this exercise often.

WORKING FROM ON-THE-SPOT SKETCHES

Having experimented with pure memory, try next to supplement your memory with quick sketches. In this exercise, study your subject for five minutes. Then whip out your sketchbook (a small size) and give yourself exactly five minutes— no more—to transcribe what you have seen. Time yourself, and don't cheat. Your effort will indeed be sketchy, but it will have its virtue. Repeat this exercise several times.

In your next experiment, allow ten minutes for mental analysis and ten minutes for the sketch. Double the time for the sketch in the next exercise. Finally, after several of these memory tests and quickie sketches from all kinds of subjects, take

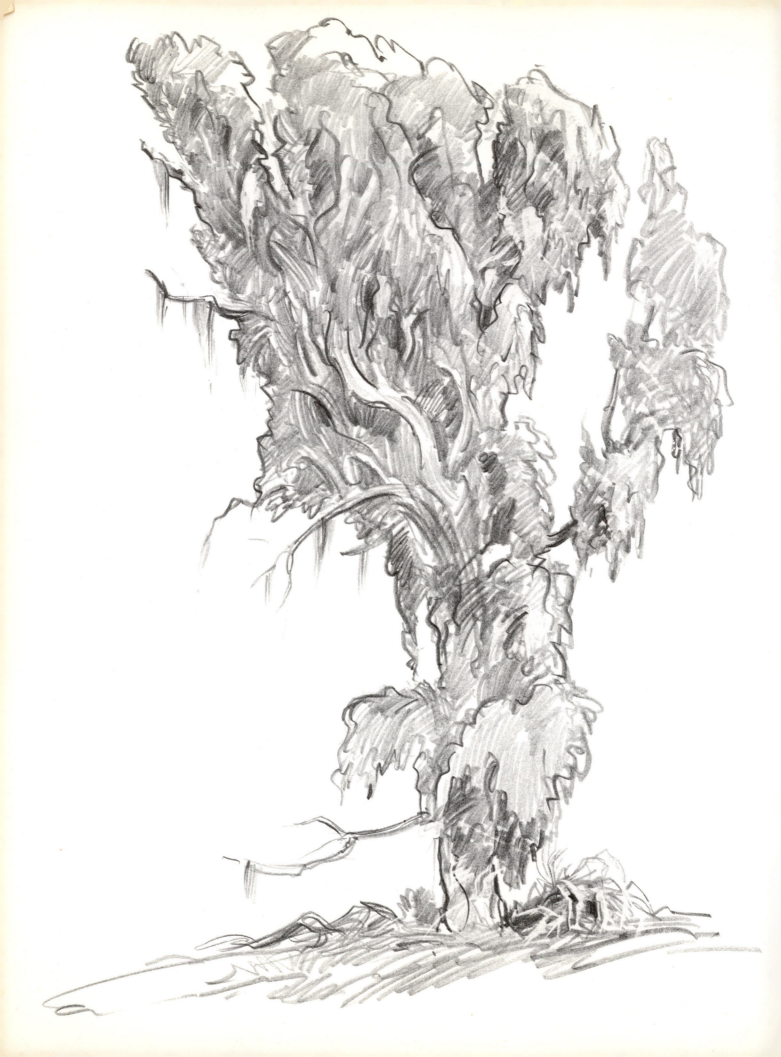

Figures 87 and 88. Ragged Live Oak Tree in North Carolina

The story of the drawing of this tree has been told in the text. Figure 87 (left) is the final drawing; Figure 88 (above) is the little silhouette sketch which I hurriedly made on the spot. In this spontaneous drawing, quickly rendered with a broad bevel stroke, I emphasized the impact of massed foliage rather than meticulous detail. Its essential characteristic is the downward flow of dominant lines.

all the time you desire to "finish" the sketch. Compare these "finished" sketches with the quickies. Which have the greatest dramatic impact?

This quick sketch approach is illustrated by my experience drawing a live oak tree (Figure 87). It was sketched somewhere in North Carolina. My wife Eve and I were driving homeward, she at the wheel—as usual when we are in territory where drawing subjects are likely to be discovered. Seeing this live oak a hundred yards ahead, I was tempted to stop to draw it. We did pull off the road to admire it; but as the hour was growing late, and we had many miles to travel that afternoon, I decided to proceed. Yet, as we drove on, I couldn't get that tree out of my mind and regretted the decision to leave it. We had traveled on about three miles when I announced: "We must go back and get that tree!" Which we did. But I contented myself with the little silhouette sketch (Figure 88), drawn in about fifteen minutes. It recorded the essential design and gave me time for sufficient mental imagery to make the large drawing that evening at our motel.

Now it is evident that this drawing was made with considerable speed, as the 6B pencil flowed down the cascading foliage and hanging moss forms and along the branches, all of which were vivid in my memory. This drawing is a good example of broad-stroke technique and vigorous handling, which contrasts with the drawing of the locust trees (Figure 89). Thus it is that conditions and moods determine what you do with your pencil.

DRAWING BY SEEING

The teaching methods of Hoyt L. Sherman at the Ohio State University are worth mentioning in connection with the approach to perceptive seeing. His approach is *drawing by seeing.* I refer here only to one aspect of the method—the basic one, really. This approach dramatically teaches the importance of what the author calls "perpetual unity," which means just what we try to achieve by the memory discipline we have described. The term means seeing the subject as a whole, rather than bit by bit.

In this method, the studio is darkened and the subject, placed in front of or on a white background, is seen by students for only a second, as it is illuminated by a flashlight. During this brief look, the student can take in the over-all impression of the model, but he has no opportunity to focus upon a single detail.

This procedure is certainly a sound discipline, and even though a student

Figures 89 and 90. Locust Trees on Cape Cod

Locust trees grow with a sinuous line which is very graceful. I must have spent considerable time on this sketch because it is meticulously studied throughout. The foliage is rendered with a scumbled line, rather than with firm direct strokes. A very soft lead was needed for the dark shaded mass, within which a few spots of sunlight filter and give the effect of depth. The foreground bushes are very lightly defined and indefinitely rendered, to serve as a base for the trees. Figure 90 (below) is a thirty-second sketch.

working alone cannot conveniently practice it, the thought of it should be helpful. As the late Maurice Sterne said, "You must draw what you have *seen* rather than what you *see*."

DEGAS' ADVICE TO STUDENTS

I came upon a word of advice to students by Degas, the great French master of drawing and painting: "After all," he said, "a painting is first of all the product of the artist's imagination, it ought never to be a copy. If afterwards he can add two or three natural accents, evidently that doesn't do any harm. It is much better to draw only what remains in the memory. It is a transformation during which imagination collaborates with memory; you produce only that which strikes the eye, that is to say, the necessary . . . retaining forms and expression. Never draw or paint immediately."

Degas went a step further. He recommended that in painting a portrait, the model should pose on the ground floor, and the artist work at his easel on the second floor.

Degas' instructions were intended for students who were painting subjects which do not concern us at the moment. They do not apply to most sketching problems, yet they do emphasize what we have been saying about the lesson to be learned in memory exercises. Degas' advice demonstrates how memory can become our teacher when we are drawing anything at all. His words have no reference to the drawings I have made of trees, wherein I worked with quite a literal attitude in trying to capture the reality of the subject before me. They do emphasize the need to develop a perceptive eye which goes to the heart of the matter, and does not become engrossed with non-contributory elements.

FOLLOWING YOUR PENCIL

Occasionally we hear novelists declare that characters in their stories frequently do and say unexpected things not consciously planned by the author. This seemingly mysterious collaboration of the "other mind" offers us a glimpse into the secret of creativeness.

The novelists' experience may help explain what I mean by following your pencil. At some stage in your drawing experience, you will discover your pencil doing things you have not consciously dictated. These spontaneous performances are indeed fundamental to creativity. Without them, you may succeed in producing tolerably good technical results, but your drawings will not have emotion or verve. They will not thrill the observer.

Is it not obvious that when we follow our pencil, we must have something for *it* to follow? That "something" is emotional experience. Don't expect your pencil to act creatively unless you are emotionally keyed up, and unless you have a backlog

of intimacy with the typical characteristics of the subject you are drawing. Such intimacy comes only through long experience of drawing all kinds of things and knowing much about their eccentricities.

There is yet another factor. Your attention must not be distracted while you draw. When this happens—as it did while I was sketching *Sorrento Street* (Figure 59)—the pencil will not help you a bit; you will have to push it. My drawing of Sorrento lacks the spontaneity which it ought to have, and so will a drawing made after a photograph—except when the artist has had first-hand communication with the subject previously, as was the case in the drawing of the sculptures in the Ogive of Notre Dame's main portal (Figure 25).

ROLE OF THE SUBCONSCIOUS

Of course there is nothing mystical about this experience of following your pencil. What happens is that your subsconscious, habituated to your thinking and working, and replete with all knowledge on file therein, has taken over responsibility for much of the technical effort of the earlier learning times, much as the pianist's fingers automatically strike the keys which once he had to select consciously.

RAPID SKETCHING

Rapid sketching is good training for such mastery when there is no time for fussing over details or worrying about technique. Keep attention focused upon form, structure, pattern, and tone and do not worry about the pencil strokes. This is more easily said than done, of course, but who said it is easy?

Perhaps the thirty-seconds sketch shown herewith (Figure 90) will be instructive in this discussion. It is a half-size identification sketch of the locust trees (Figure 89) which is reproduced at the exact size of the original. When organizing this book I made half-size "quickies" of every drawing I planned to include in the book. These small sketches were then attached to my studio wall, where I could select from them the subjects to be used. The entire book was thus spread out before me for study. This is my customary practice.

The little sketches are so scrappy that many of them could be identified by no one but me. If you compare the miniature of the locust tree with the original drawing, you will note that the sketch is only approximate in its resemblance. I show it here to demonstrate that my pencil could not help making a sketch which characterizes the undulating action of branches and would serve, if asked, as the basis of a very interesting tree form. Without making any noticeable changes, I could create a very attractive locust tree. Unconsciously, I made a good form, and the pencil gave me quite definite hints for branch structure.

In conclusion, I would say that this phenomenon of following your pencil is really the goal of the sketching student.

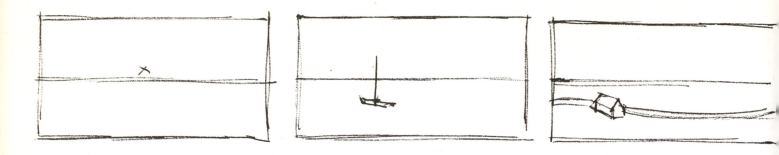

Figure 91. Sketches to Illustrate the Power of Imagination

The artist should be ever mindful of his audience's imagination and its creative role. The sketch at the left is merely a rectangle divided horizontally by a line, devoid of pictorial suggestion. A boat sketched crudely in the lower half (center), transforms the rectangle into water and sky. Substitute a house for the boat (right), and you have land and sky. The viewer's imagination automatically translates the untouched paper above line X into sky.

IMAGINATION

The vitality of the sketch depends notably upon imagination—not only the artist's, but also the imagination of all who view the sketch. The artist should be ever mindful of his audience's imagination and stop short of introducing extraneous detail which can be boring—in the manner of an awkward story teller who ruins the spontaneity of his anecdote by undue embellishment.

The sketch presents the *essence* of the idea, inviting the imagination of the audience to complete picturization to his satisfaction. The participation of the audience in this regard is illustrated, in part, by reference to Figure 91. (A) is merely a rectangle divided horizontally by the line X. It is devoid of pictorial suggestion. Sketch a boat, however crudely, in the lower half (B) and transform the rectangle into water and sky. Substitute a house for the boat (C) and you have land and sky. It is unnecessary to do anything about the sky: it is automatically illustrative when the area below line X becomes water or land. Thus white, untouched paper becomes translated into objective reality. The more expert we become, the more we learn to use untouched paper as part of the picture.

No one understood this artifice better than did the great master Rembrandt. See what he did with a few lines in this drawing of a winter landscape (Figure 92).

DISTINCTION BETWEEN A DRAWING AND A SKETCH

The artist does not always want to treat his subject in such a shorthand manner. Often he prefers to delineate with illustrative completeness as in, for example, *The Portrait of an Egret* (Figure 81), which I call a drawing rather than a sketch.

This brings us logically to the question, "What is a sketch?" and "What is a

132

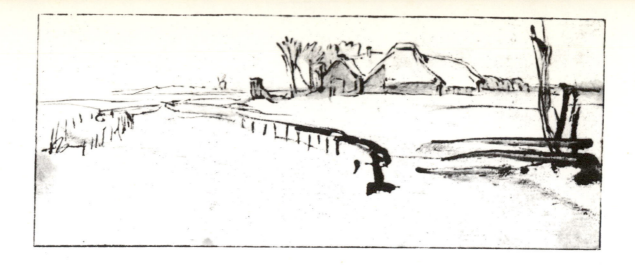

Figure 92. A Winter Landscape, by Rembrandt Van Rijn

No one understood how to use untouched paper as part of a picture better than the great master Rembrandt. See what he did with a few lines in this drawing of a winter landscape. Courtesy, The Fogg Art Museum, Harvard University.

drawing?" The distinction between them may seem unimportant, since each type of rendering may commonly be referred to as either sketching or drawing. But one's attitude toward the work differs greatly. The act of drawing is synonymous with delineation. In drawing the palm tree in *Portrait of an Egret,* I was enamored with its beauty and I endeavored to represent it completely with my pencil. Nothing but its *color* remains to be imagined by any person who sees it. The same can be said of many other drawings here reproduced, particularly those of trees, which usually I draw as dramatic manifestions of the universal creative mind—not hesitating to change the growth structure for better design appearance. The drawing of the tulip in the chapter on *Looking and Seeing* would not be classified as a *sketch,* as is evident when reading the text accompanying it.

CREATIVE ROLE OF UNTOUCHED PAPER

The intention of this chapter is primarily to convince the reader that untouched paper is a creative part of the sketch. If you inspect the drawings throughout this book, the concept will be evident. The sketch *Ponte San Lorenzo in Venice* (Figure 19) shows the barest indication of buildings beyond the bridge; however, the suggestion is sufficient, along with imagination, to complete adequately the environment in which the bridge and the boats constitute the essence of the composition. In all my drawings, the interplay of untouched paper with penciled areas is an essential feature of the allover effect. If one attempts to cover entire areas of a subject with tone—as the painter customarily does—the result will be labored and dull. White accents which break into even those parts which are tonally treated (such as the

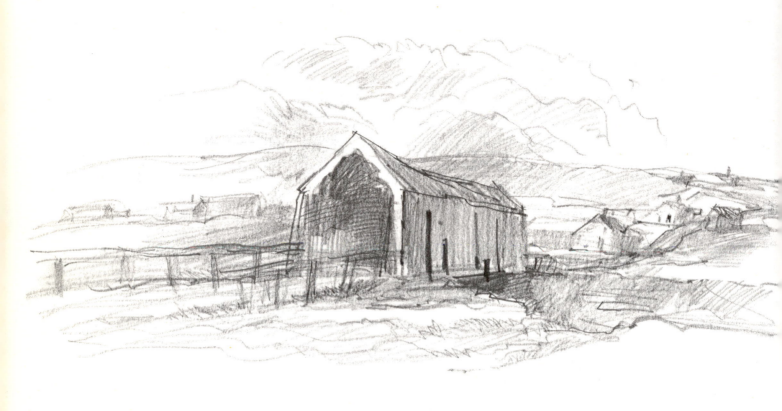

Figure 93. Road to Therapy

I have commented upon this drawing in the text, but I might add some technical notes. The drawing, on Alexis paper, was probably done with a simple soft lead, possibly a 4B. The tones are largely scumbled, as are the lines which outline forms and indicate landscape formation. The clouds seemed an essential aspect of this sketch, as they enfold the rolling hills. The road rambles in an undulating fashion without being quite sure of its destination. It is indeed lost in indefiniteness beyond the buildings.

darkness of an open door), give sparkle to a drawing and enhance through contrast the impression of dark space.

IMAGINATION AND EXPERIENCE

There is another kind of imagination; it is used by the artist when he makes up a picture "out of the blue." "Out of the blue" does not mean pure invention out of nothing. Imagination draws its content from memory or experience, the stuff accumulated by the senses over years of keen observation. In imaginative drawing, we dip into our storehouse for inspiration and for visual memories. We can juxtapose the remembered forms, distort them, and give them fresh connotations. In that sense, they become new creations. At any rate, they have their value. They are useful when, for one reason or another, sketching outdoors is impractical.

Of course one has to start with something familiar, as I did when I drew the subject I called *Road to Therapy* (Figure 93), because the sketch—made at 2:00 a.m. during a sleepless night—was indeed therapy. Here the covered bridge, once so common in New England, was the starting point. Then the road began to meander over rolling hills into the distance, rambling more by accident than by scheme.

In *Barbiturate Park* (Figure 94), I began with the tall building. From then on, the sketch grew without any preconceived plan, a process of accidental addition. Of course, it is not necessary to wait upon the need for therapy for one to do this sort of thing; two o'clock in the afternoon is as good a time for it as two in the morning—even better.

Other rainy-day sketches (let us call them that) may start with pictures which serve not as copy but as suggestion. The drawing which I named *Rocky Hollow* (Figure 95) falls into this category. It began with a newspaper photograph and some rocks in New York's Central Park, and developed into something as unlike the photograph as could be. The photograph served only as a point of departure.

This kind of creative drawing is profitable discipline because it compels one to summon ingenuity; and it encourages a more creative attitude when one sketches outdoors directly from the subject. Very often, the best subject one could wish for is enhanced by the addition of some made-up accessories.

IMAGINATION AND IMPROVISATION

I had planned to write a chapter on *improvisation,* but, as I explored the subject, there seemed to be such a tenuous distinction between it and *imagination* that I decided to place two improvised drawings of trees intended for the former to this chapter. The first (Figure 97) is a memory-improvisation of jungle growth that lines Route 17 in Georgia. The foliage fascinated me and I would have stopped to sketch it had this been possible. But in that rather narrow two-way highway—as it was in 1963, anyway—there were no turnouts for miles. It was just as well, in this

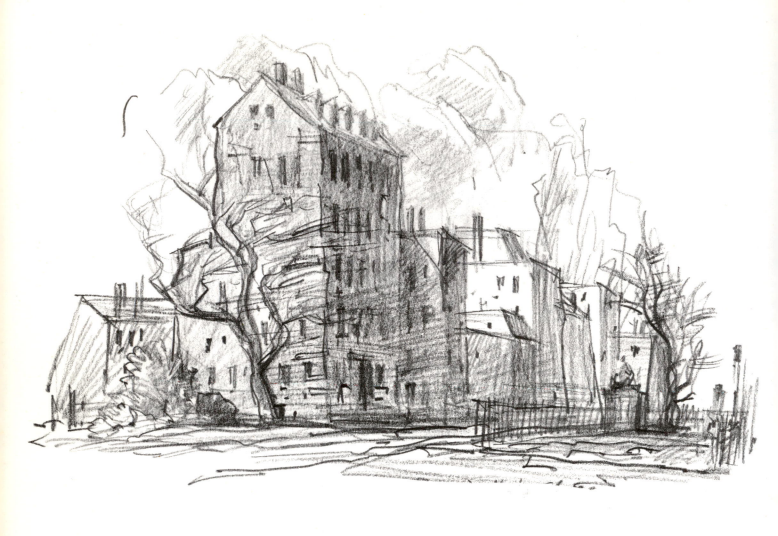

Figure 94. Barbiturate Park

This is an impossibly conglomerate group of buildings. As a sketch, it is evidence of complete indifference to the result. Yet, sometimes sketches made with this kind of abandon bring out qualities that have their own validity. For example, the clouds are important to box in the rising buildings. The drawing was done with a single soft lead on a paper such as Alexis.

136

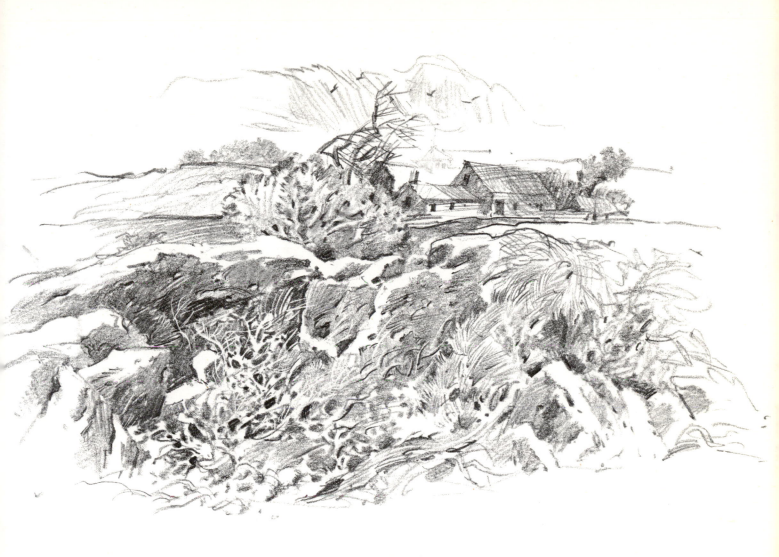

Figures 95 and 96. Rocky Hollow

This largely imaginary drawing started with a newspaper photograph of a rocky glen in Central Park, New York City. My drawing turned the photograph into something quite different. The rocks themselves were extremely attractive in form and texture. When I began to draw, I continued to develop my own composition with made-up rock forms drawn from memories of rock characteristics, stored up over the years. One would think rocks would be easy to improvise, but this is not the case. They have their own anatomy, which the artist has to discover through experience. The tangle of brush in the depression gives much interest to this drawing (Figure 96, at left, is a detail of this area). The drawing was made on clay coated paper, so that some of the delicate white twigs could be scraped out of the dark rock mass. I "got out of the picture" at the right side by lightening the tonality of rock forms and by introducing grasses and a dead limb to create rhythm at that point.

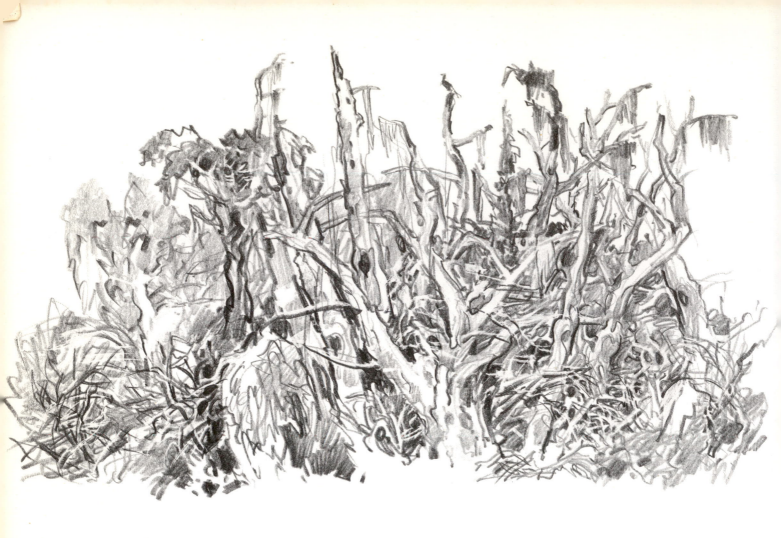

Figures 97 and 98. Dead Trees in the Jungle along Route 17, Georgia

I drove for miles on this highway, which was bordered by swamps and filled with dead jungle trees. It was impossible to stop on the narrow road, so I had to depend on memory. I suppose photographs might help at such times, but the camera is dictatorial, while memory releases creativeness. I am very fond of this drawing because it encompasses great technical variety. If it is studied very carefully, the contrast between broad-stroke, and fine, delicate line (both in black and white) is obvious. Although one gets the impression of utter confusion of form and line, the composition is rather carefully designed. The accompanying line sketch (below) reveals a stabilizing group of branches and foliage which anchors the entire composition.

case; all I needed for my improvised rendering was a generalized memory of the chaotic effect and an ability to weave these broken forms into a contrived design.

The other sketch (Figure 99), which I have labeled *Fallen Trees,* is ninety-five percent improvisation; this drawing was motivated by three uninspiring stumps standing in a desolate field which faced a parking lot where I sat waiting for my wife. I made a rough sketch of those stumps on a scrap of paper (there are times when we draw because we have to, regardless of our interest in what is before us). Back home, I contemplated the sketch and began playing with that tree. The subject grew, imagination supplying tumbled branches disintegrating where they fell.

I get much pleasure from exercises in invention which probe the mental files for memories to supply the factual elements for improvisation. I think such exercises are good practice for landscape students, whatever their media. They train not only the creative faculties, but also the perceptive eye in on-the-spot drawing.

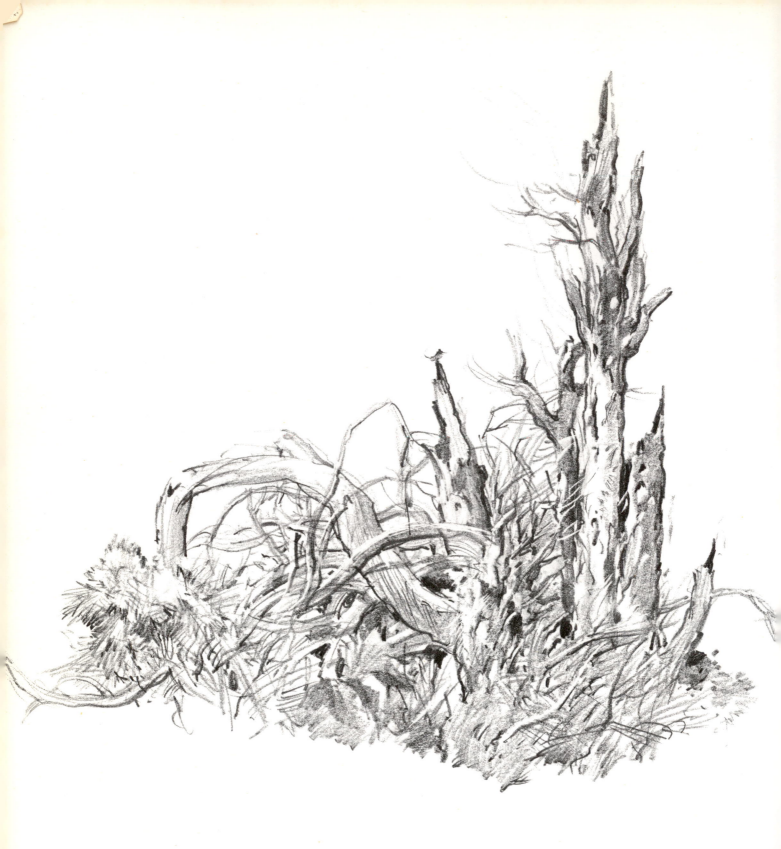

Figure 99. Fallen Trees

This sketch is almost entirely "made-up." I drew the upright stumps from memory and amplified them with improvised fallen branches. I might point to the technical variety here employed—broad-stroke and sharp line, with a little scraping out.

GALLERY OF PENCIL DRAWINGS

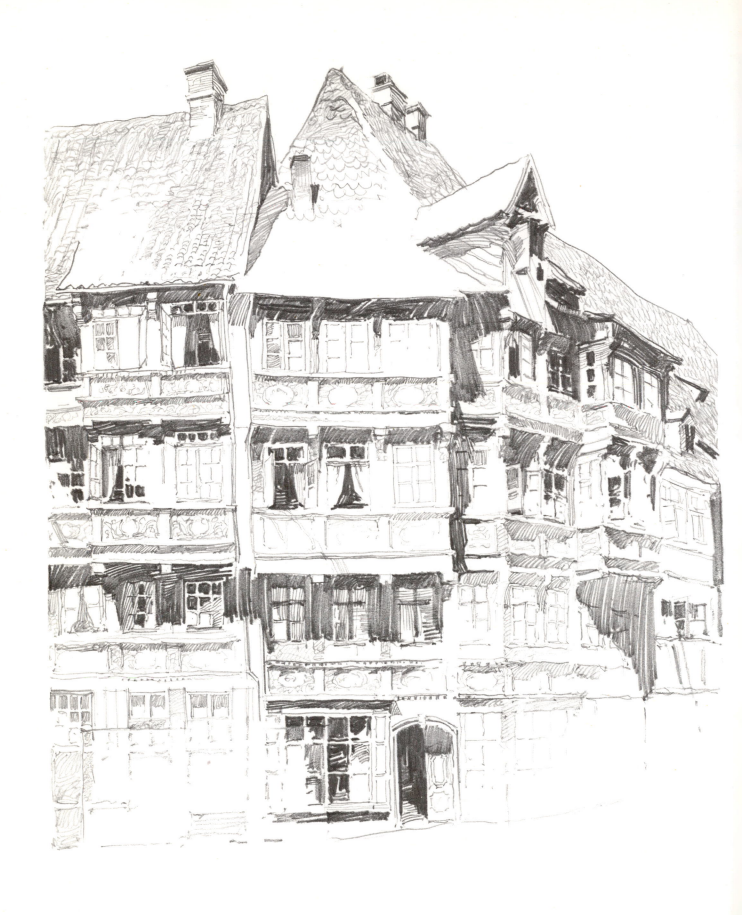

◄ **An Old House at Hildesheim**

Here is another example of selective detail in a drawing which appears to be more finished and more elaborate than it really is. Examine the roofs, for example, which have intricate tiling that is simply rendered by a pattern of wavy strokes that are hardly more than doodles. The same kind of stroke is used for the architectural details surrounding the windows. The windows themselves range from fairly finished rendering, in which most of the panes and mullions appear, to mere suggestions handled with a few vertical and horizontal strokes. The use of deep blacks for shadows is also highly selective.

▲ **Shipping in the Boat Basin at Rockland, Maine**

This is one of many sketches I made in the summer of 1956. The freight schooner moored alongside an old barge made an attractive subject. I improvised the lobster pots in the left foreground as a counter balance for the dark barge cabin. Notice that the side of the schooner is made very light at the stern for the sake of contrast with its dark shading. Those vertical dark strokes on the barge's side are arbitrary, technical and compositional effects.

Hotel Alamo, Old Tucson, Arizona ▲

This is obviously a rapid, casual sketch in which quick, horizontal and vertical lines serve to indicate the rough old boards of the wooden buildings. Compare the very sketchy rendering here with the far more polished handling of Gothic architecture in drawings reproduced elsewhere in the book. In this case, the rough handling and swift, almost scribbly pencil strokes are entirely in keeping with the ramshackle nature of the subject.

An Ancient Willow in Valhalla, New York ▶

This drawing was made with a charcoal pencil on a fine day in June. It was rubbed here and there with a moistened finger; and, since the paper was clay coated, some important effects were scraped out with a sharp razor blade. I seldom draw with charcoal or carbon pencils, but I resorted to the charcoal pencil in this instance because I wanted to render the tree foliage in larger and less broken tone masses than is agreeable with graphite pencils. The dense foliage obscures most of the branch structure.

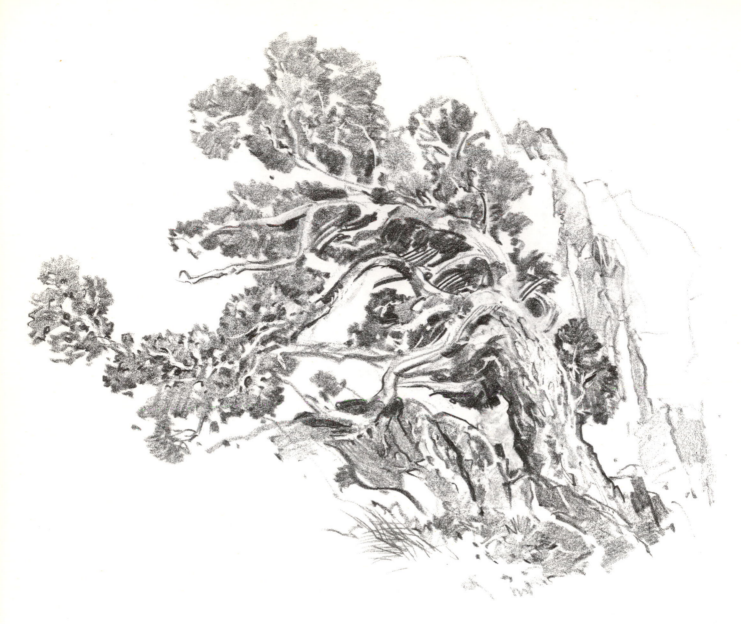

▲ Souvenir of Kitt Peak, Arizona

The foliage of this rugged specimen is sparse in proportion to the trunk and branches. The texture of the battered trunk testifies to its age. This wind blown conifer is characteristic of trees which manage to survive the rigors of cold, snow, and wind. They grow close to the timberline on Kitt Peak, high on the summit of the Quinlan Mountains. There, an unusually clear atmosphere attracted astronomers, who built an observatory which houses the world's largest solar telescope. The drive up to the Kitt Peak Observatory is thrilling.

Cathedral at Burgos, Spain ▶

The apparent precision of this architectural drawing is deceptive, for the handling of the pencil is actually quite free. The intricate Gothic detail of the tower, for example, consists simply of impressionistic dabs with the chisel point that give the illusion of far more careful rendering. Note how loosely the windows are sketched, with a few lines simply suggesting occasional mullions and panes of glass. The Spanish roof tiles in the foreground are roughly indicated with curving strokes that suggest their form without actually rendering a single tile completely.

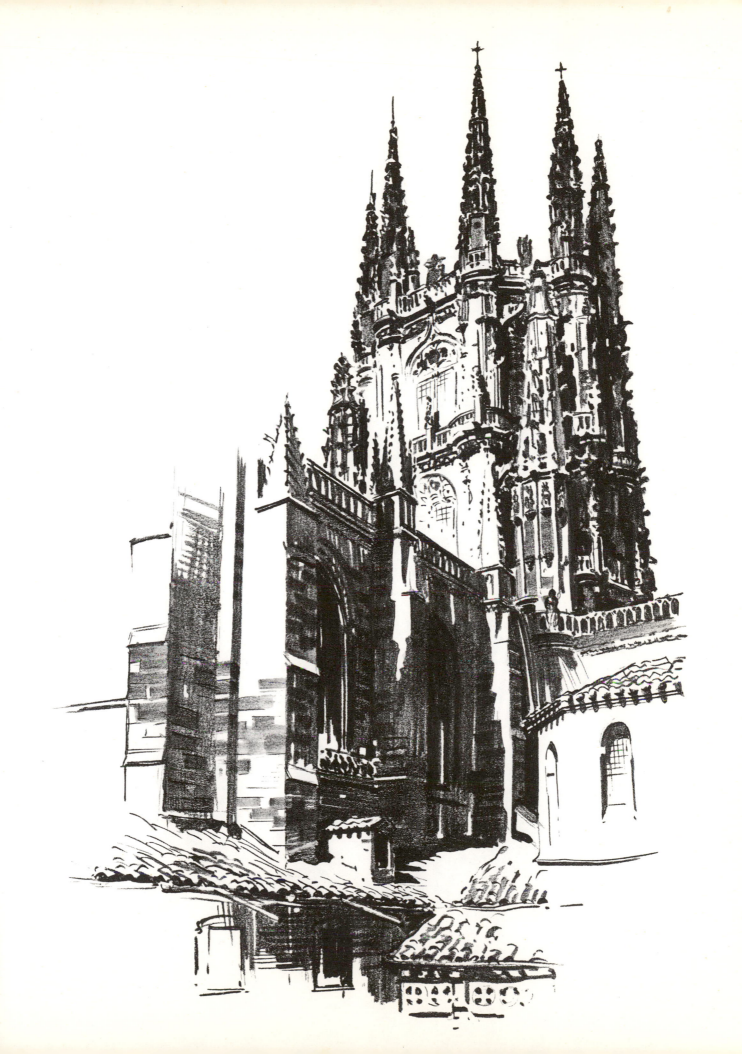

◄ Gargoyles, Notre Dame Cathedral, Paris

In drawing this, I was amused by the companionship of the imaginary stone bird and the real pigeons. The gargoyle is drawn mainly with curving strokes that follow the form of the feathers and thus reinforce the curving design within the sculpture itself. As I frequently do, I have allowed occasional blanks between the strokes where the white paper comes through to give an effect of liveliness and informality. Notice how the strokes follow the form in the other architectural details such as the concave stone work in the foreground. For obvious reasons, the living birds are drawn with freer, more casual strokes than is the stone one.

▲ Broken Flower Pot

The simplest, least pretentious subject often offers the most delight in rendering. Such humble subjects, when deeply experienced in the manner described in the chapter on Looking and Seeing, *are as rewarding to the artist as the more universally intriguing still life group. One might point out here the manner in which I developed the deep shadow tone—with very soft leads, of course, and white strokes between the leads to keep the shadow vibrant. It seemed natural to give the strokes a swirling direction following the contour of the curved interior.*

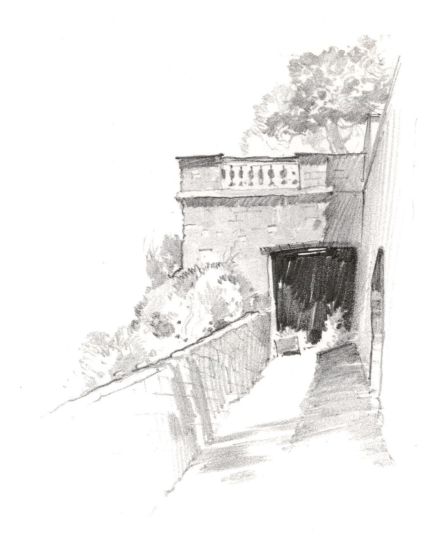

On the Path Up the Cliff, Sorrento, Italy ▲

It is often interesting to see how much can be done with a very modest subject. Here we have nothing more than a path, a wall, a fragment of architecture, and some foliage, yet the drawing is dramatized by the convergence of the path and wall into the deep darkness of the doorway, which becomes the focal point of the drawing. This is a good example of the way in which the viewer's attention is controlled by the manipulation of values. The darkest note in the drawing is the center of interest, and the tones gently graduate to white paper at the edges.

Detail, King Lear Panel, by John Gregory, Folger Shakespeare Library ▶

Here the dramatic design element is the sweeping drapery, which is handled with bold, rhythmic strokes that express the movement of the folds. The drawing is in a relatively high key, with very selective accents of dark in such places as the fists, behind the head, and in the area of the sleeves to call attention to the upper part of the figure. Notice the vignette effect as the right hand side of the figure melts away into white paper.

Banyan Trees, Coral Gables, Florida

I made this meticulously accurate and detailed drawing because these banyans were the most dramatic I had seen. It was a labor of over two hours. The rhythmic intertwined pattern of the trunks and branches had to be carefully observed, particularly because this pattern was thrown into bold relief by dark strokes drawn between the lighter forms. Compare the long, rhythmic strokes of the trunks and branches with the short scribble strokes used to render the texture of the foliage. The strip of shadow at the bottom of the drawing is particularly important to anchor the trees to the landscape.

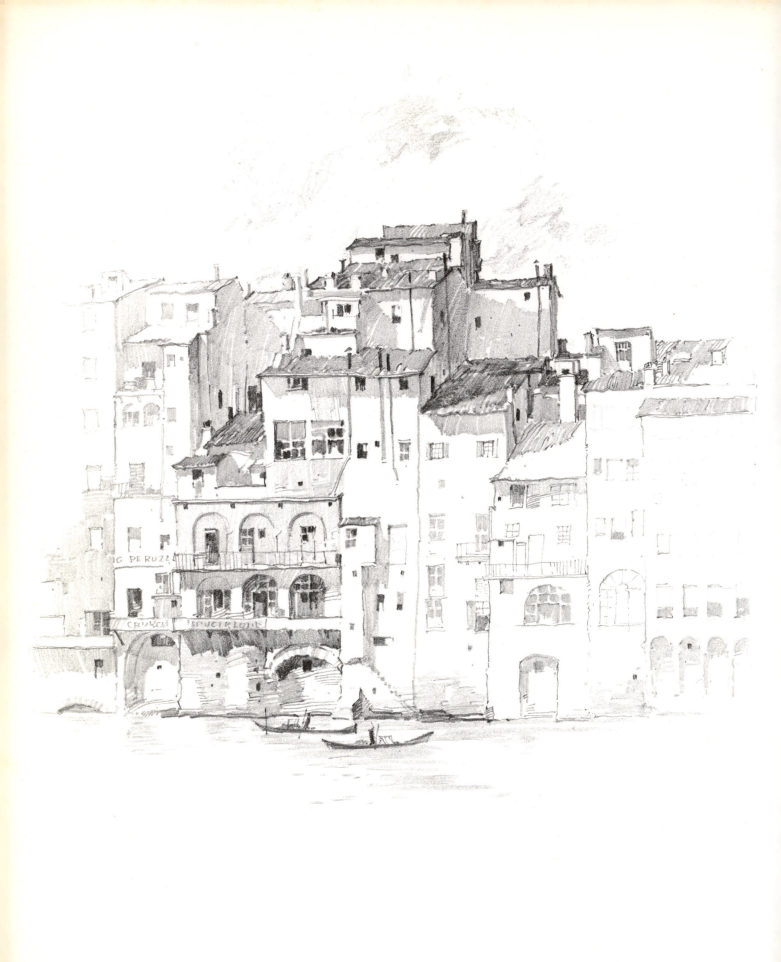

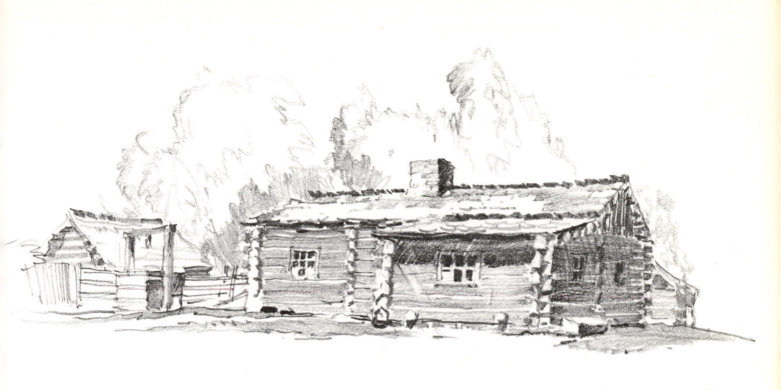

◄ Old Houses on the Arno, Florence

In sketching these houses across the Arno from my hotel room, I made an arbitrary pattern of tone to avoid what might be tonal monotony. After drawing all the structures in outline, I proceeded with a medium-soft lead to tone the most interesting detail, which has a deep cast shadow and the curved form of an arch. From there, I spread the tone upwards to culminate in the light and shadow of the roof formations.

▲ Log Cabin at New Salem, Illinois

This is one of many structures in the restored old village, made famous by the residence and the activities of the young Illinois rustic, Abraham Lincoln. Quite naturally I used broad strokes that follow the construction of the horizontal logs. The roof shingles were selectively rendered to create a pleasant pattern. The trees behind the cottage are represented suggestively, with only enough tone for definition. Their shadows integrate with the building as a part of the tonal design.

Trees at Boynton Beach, Florida

Frankly, I did not know the species of this tree and had never seen deciduous trees grow this way. I seem to have spent considerable time in meticulously reproducing the tree structure. Then, apparently eager to be through with it, I scumbled a rapid foreground with a very free and playful broad-stroke which may be the best part of the sketch.

Edited by Judith A. Levy
Designed by James Craig
Composed in twelve point Garamond
by Howard O. Bullard Typographers
Printed and bound by Interstate Book Manufacturers